ERIC GILL

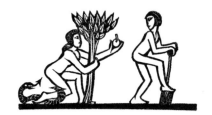

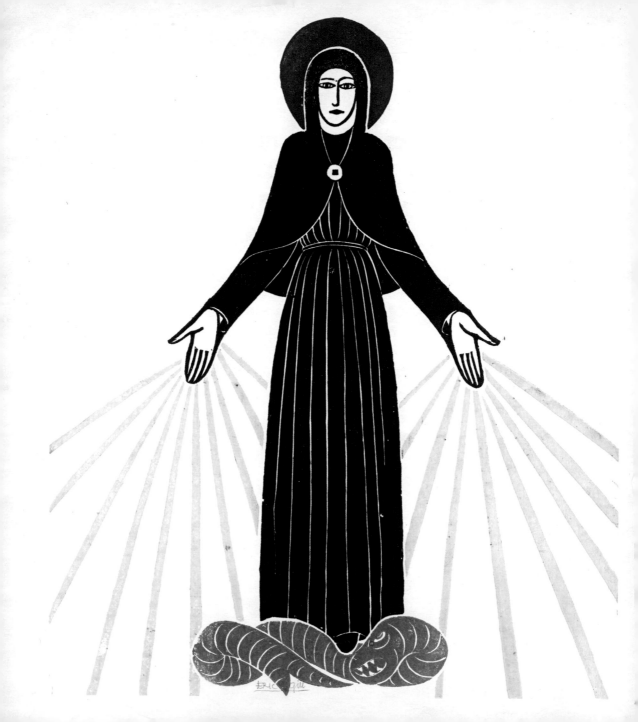

ERIC GILL

Lust for letter & line

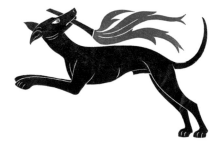

Ruth Cribb & Joe Cribb

THE BRITISH MUSEUM PRESS

For Marcus and Margaret

© 2011 The Trustees of the British Museum

Ruth Cribb and Joe Cribb have asserted the right to be identified as the authors of this work.

First published in 2011 by the British Museum Press
A division of the British Museum Company Ltd
38 Russell Square, London WC1B 3QQ
www.britishmuseum.org

A catalogue record for this book is available from the British Library.

ISBN 978-0-7141-1819-2

A NOTE ON THE TYPE This book is set in the typefaces Perpetua and Gill Sans, both of which were designed by Eric Gill.

A NOTE ON IMAGES The majority of the images in this book are from the collections of the British Museum. The British Museum registration numbers are listed on page 111. For further reading, please see page 110.

PAGE I *Adam and Eve*, 1917. Wood engraving, illustration for *God and the Dragons*, a book of poetry by Douglas (Hilary) Pepler, St Dominic's Press, 1917. 39 x 56 mm.

PAGE II *Our Lady of Lourdes*, 1920. Woodcut, poster design for St Dominic's Press. 288 x 243 mm.

PAGE III AND INSIDE COVER (BACK) *Hound of St Dominic*, 1923. Woodcut, poster design for St Dominic's Press (see also page 108). 260 x 175 mm.

PAGE V *Naked Youth* and *Naked Girl Looking Back*, 1927. Wood engravings; decorative borders for Geoffrey Chaucer's *Troilus and Criseyde*, Golden Cockerel Press, 1927. 178 x 97 mm. (See also pages 94 and 95.)

INSIDE COVER (FRONT) *Sculpture no. 2*, 1930. Wood engraving described by Gill as 'experiment with multiple tool' (an engraving tool for cutting several lines simultaneously). 317 x 258 mm. PD 1949, 0411.5103 (Given by Campbell Dodgson).

Designed by Pencil Ltd
Printed in China by Toppan Leefung Printing Ltd

The papers used in this book are recyclable products and the manufacturing processes are expected to conform to the environmental regulations of the country of origin.

CONTENTS

INTRODUCTION

Eric Gill (1882–1940) was 'one of the most remarkable personalities of his time, able to express what was in him as a carver, engraver, typographer and writer, and above all, perhaps, as a courageous, clear-sighted and particularly lovable human being,' said Sir John Rothenstein, Director of the Tate, in 1958.

Gill was invariably shown in photographs with a pencil, chisel or graver in hand. He had a passion for the lines created with these tools, and all his artwork started with a drawing on paper. A prominent British avant-garde artist, Gill participated in the development of new forms of sculpture, engraving, letter cutting and typography in the early twentieth century. Above all Gill was an artist who worked to bring to his varied media the overarching importance of 'good drawing', by which he meant 'good lines ... clean lines, clear lines, firm lines, lines you intend' (*25 Nudes,* 1938; see page 85). His insistence on the religious dimension of art makes his contribution a unique one. For Gill 'good' had an added meaning: 'Drawing is worth doing for its own sake; it is subordinate to no other end than the general end of life itself – man's final beatitude' (*25 Nudes*). These remarks preface nude engravings of his mistresses, but Gill, son of a clergyman and member of the Dominican Order, saw no

Self-Portrait, 1927. Wood engraving, signed by the artist, printed 1929. 180 × 125mm.

conflict between his religious views and his remarkable and now infamous sex life.

Gill's 'good lines' in both image and letter are illustrated here largely by works from the British Museum, supported by examples from the libraries of the University of Notre Dame, Indiana, and the University of California, Los Angeles, from Ditchling Museum, Sussex, and the Royal Mint Museum, Llantrisant. Further pieces come from a private collection.

Eric Gill in Sussex and London

Growing up in Brighton and Chichester, Gill had a childhood engagement with drawing, which led him to study technical drawing at college. In 1900 he became an apprentice draughtsman with an architect in London, where he enrolled in evening classes in stonemasonry at Westminster Technical College and calligraphy at the Central School of Arts and Crafts. In 1903, guided by his calligraphy teacher Edward Johnston (1872–1944), the founding father of modern calligraphy, Gill abandoned his apprenticeship to set up business as a decorative and inscriptional letterer, with commissions to cut memorial inscriptions in stone and to design title pages for books.

Gill admired Johnston and they became close friends. When Johnston moved to live in the Arts and Crafts community in Hammersmith in 1905, Gill followed. There they met a young social worker called Douglas Pepler (later to take the name Hilary Pepler; 1878–1951), with whom they shared

GLORIA IN ALTISSIMIS
DEO
ET IN TERRA PAX
HOMINIBUS BONAE
VOLUNTATIS

Gloria, 1906. Inscription in Hoptonwood stone, illustration for Gill's appendix 'Inscriptions in Stone' in Edward Johnston's *Writing & Illuminating & Lettering*, 1906, a 'handbook on the artistic crafts' (Ditchling Museum). 141 × 85 mm.

the Arts and Crafts movement's passion for medieval craft traditions. Gill became active in Arts and Crafts organizations and the socialist Fabian Society, learning much from these movements, but later distancing himself from them. His interest in the medieval soon extended to lifestyle, and in 1907 he moved to the small village of Ditchling in Sussex in order to create a life more connected to medieval ways of working. He took his young family and his apprentice, Joseph Cribb (1892–1967), with him, and later Johnston and Pepler followed with their families. In Ditchling Gill continued his letter-cutting business, but also began making wood engravings and

sculpture. He remained involved with his London circles, meeting with many artists, most importantly the sculptor Jacob Epstein (1880–1959), whom he met in the British Museum in 1908 and worked with in Ditchling in 1910. In 1913

View of Ditchling, 1918. Wood engraving for the Women's Institute, Ditchling, Sussex. 20 × 59 mm.

Gill and his wife converted to Catholicism. Pepler also became a Catholic and in 1916 set up the St Dominic's Press in the village, to disseminate his and Gill's views and print Gill's engravings. In 1920 Gill and Pepler established the Catholic craftworkers Guild of St Joseph and St Dominic, based on their understanding of medieval monasticism and craft guilds.

Through the Guild and Pepler's press, Gill hoped to precipitate wider social change. Gill's illustrations for the press, as well as the imagery of some of his commissions, were deliberately provocative towards the established religious and political order. The anti-capitalist and anti-industrialist attitudes of the founder members attracted a number of other Catholic craftsmen to the Guild. The Guild survived until 1989, but Gill had already left in 1924 to establish a new artistic and religious community in the remote ex-monastery of Capel-y-Ffin, South Wales.

Circular Device, 1916. Wood engraving illustrating a poem by Douglas Pepler in *The Game*, a magazine published by St Dominic's Press. 190 × 130 mm. The poem and the pen, printer's dabber and graver in the engraving refer to the magazine's founders: scribe Edward Johnston, printer Douglas (later Hilary) Pepler and engraver Eric Gill.

THE SCRIBE

The Scribes have sinned and yet do Scribes record
The Birth and Death and Rising of our Lord.
May my pen ne'er miss-spell His Blessed Word.

THE PRINTER

The Word of God became flesh on this day.
By this word of man do I labour and pray
That God's good Word be not taken away.

THE ENGRAVER

The Word is God. Now may He give me grace
By wood and stone His Beauty to embrace!—
For they are saved to whom He shows His Face.

Eric Gill in Wales and Buckinghamshire

Gill's brief stay in Wales was very creative. By the time he left in October 1928, he had begun a close collaboration with Bristol bookseller and publisher Douglas Cleverdon (1903–87), who acted as Gill's agent and published a collection of his engravings (1929). Gill also began illustrating books for Robert Gibbings's (1889–1958) Golden Cockerel Press. Although he created only a few sculptures in Wales, it was here that he designed his first typefaces and embarked with Gibbings on new approaches to book design. The remote location, however, was too challenging for Gill. During his last year based in Wales, Gill spent increasing amounts of time in London and rented a studio in Chelsea, where he completed the sculptures needed for his solo exhibition at the Goupil Gallery in February 1928. For this he carved the monumental *Mankind* (now owned by the Tate and displayed at the Victoria and Albert Museum). He left Wales with an established reputation as a leading sculptor, book illustrator and typographer.

Gill's new rural retreat was Pigotts, a former farmhouse in Buckinghamshire, bought with the proceeds from selling *Mankind*. Being closer to London made it easier for him to deliver major public sculpture commissions: the London Underground headquarters (1928–9), the new BBC building (1931–3), the Palestine Archaeological Museum in Jerusalem (1934) and the League of Nations headquarters in Geneva (1937–8). In Pigotts, Gill also established his own printing

Eve, 1935. Wood engraving, bookplate for Jacob Weiss, signed by the artist (see also page 83). 103 × 68 mm.

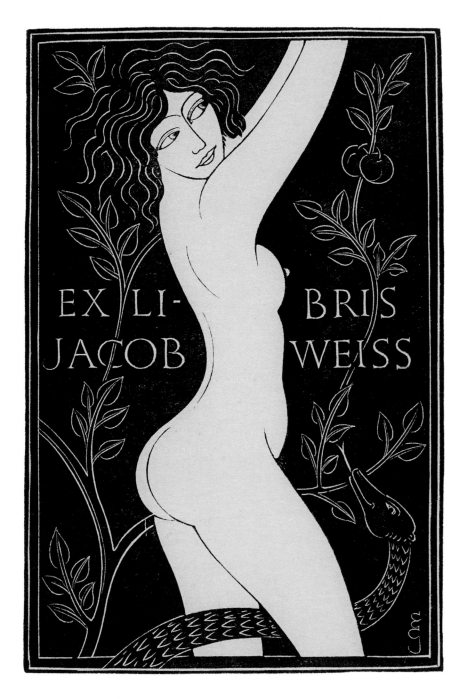

13

press with his son-in-law René Hague (1905–81), the Hague
& Gill Press. Graphic artist Denis Tegetmeier (1895–1987),
another son-in-law, also lived at Pigotts and helped with letter
cutting and other jobs in the workshop. By this time, Gill was
merely sketching many of his inscriptions and leaving them
in the capable hands of his primary assistant, Lawrence Cribb
(1898–1979), Joseph's younger brother, who had joined Gill in
Capel-y-Ffin and accompanied him to Pigotts.

In the medieval workshop environments Gill created
for himself at Ditchling, Capel-y-Ffin and finally Pigotts, he
became an incredibly prolific artist, producing 300 sculptures
and reliefs, more than 800 inscriptions and almost 1,000
engravings. He also designed 11 printing fonts and wrote more
than 50 books and tracts. He is remarkable among artists of
the early twentieth century in this range of media. His work
often combined techniques, adding inscriptions to many of
his sculptures, and carvings to his inscriptions. He carved
very low reliefs in stone using the same linear technique as in
his wood engravings and turned some of his wood-engraving
blocks into small sculptures. To maintain this amount and
complexity of work, Gill relied on a workshop of assistants.
His work on the Westminster Cathedral *Stations of the Cross*
(see pages 56–7), for example, was completed with the help of
Joseph Cribb and other assistants.

Crucifix, 1917. Wood
engraving signed by the
artist. 128 × 82 mm.
Gill modelled this on the
Crucifixion depicted in
York Minster's fourteenth-
century stained-glass
'Pilgrimage window'. Gill
was as inspired by medieval
art as he was by medieval
craft traditions.

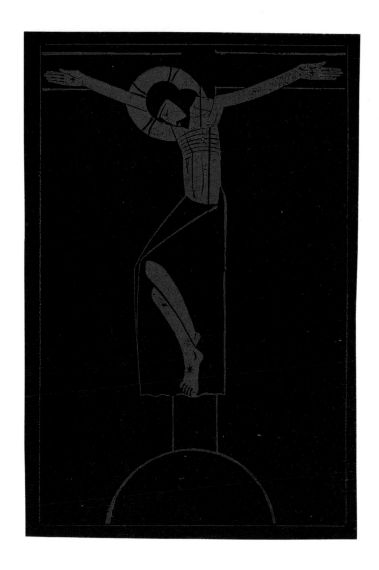

Contradictions

Gill vigorously promoted the idea of 'direct carving', the bringing together in one person of both the design and the execution of sculpture. However, his use of many assistants to aid him in his work, some even executing entire inscriptions or sculptures, seems to contradict what he wrote and points to complexities in Gill's art, writing and life. Complexity can also be seen in the apparent conflict between Gill's religion and his attitude to sex, and his condemnation of industrialization alongside his successful work with the machine type-cutters at the Monotype Corporation. Likewise, Gill presented his self-imposed 'exile' in Ditchling, Wales and Buckinghamshire as a rejection of the immoral, irreligious and over-industrialized city of London, despite maintaining an active involvement in the London art scene throughout his life. Gill's contempt for the status quo did not prevent his accepting many public commissions, but he often sought to subvert his clients' intentions by offering them veiled religious imagery: for example, the hands of his Ariel for the front of the BBC building bear the stigmata of Christ.

These apparent contradictions do not, however, detract from Gill's care and attention to the task in hand, as described by his former friend and collaborator Hilary Pepler: 'The first thing which must have struck an observer of Gill at work was the sureness and steadiness of his hand at minute detail; the assurance and swiftness of

a sweep of line is one thing (and in this he was a past master), but the hairs of an eyelash another – and he liked to play about with rays and hairs which can hardly be distinguished with a magnifying glass.'

For Gill, religion and art are inextricably linked – to labour in the making of art was labour in the name of God, as in his 1927 essay 'Christianity and Art': 'It is to be noticed … that in a religious period art, as such, is scarcely talked about at all. It is taken for granted as being simply "the well doing of what needs doing".' Gill's attention to good line, developed in the invention and execution of a new style of cutting letters in stone, created his reputation and led to his much-respected mastery of wood engraving, sculpture and typography. In all his chosen media he was at the forefront of a revolution in style and technique. His prolific essay writing and lecturing moved him beyond his passion for change in the meaning and practice of art, religion and sex, to challenging the workings of wider society.

Eric Gill, Order of St Dominic, 1934. White metal portrait medal by George Friend, from a design by Gill (see also pages 46 and 66). 43mm (diam.).

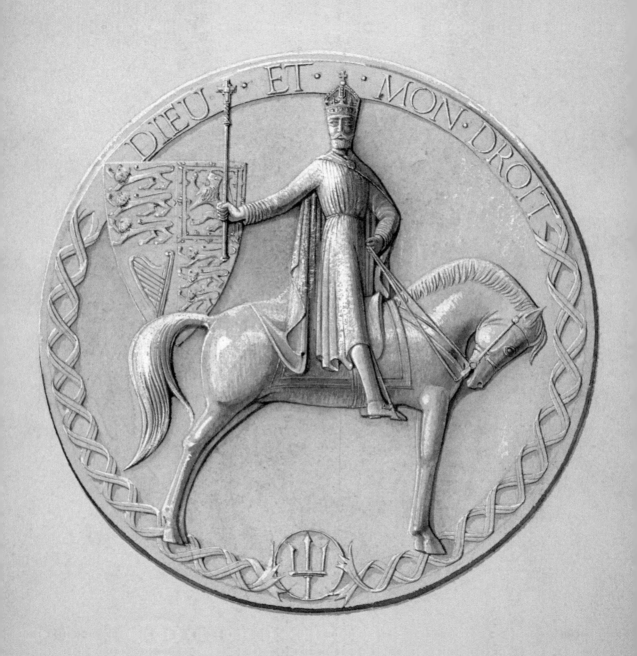

THE PAST

Gill's diaries record frequent visits to London museums and art galleries to look for sources for his lettering and inspiration for his art. On 10 November 1910 he wrote that he went 'to exhibit of Post Impressionists at Grafton gallery in noon with Jacob [Epstein] & Brit Museum after'.

Like many of his contemporaries in avant-garde circles in London, Eric Gill used the British Museum's collections. Their ancient and culturally alien sculpture and artefacts provided a rich source of inspiration for Gill, as they did for other sculptors such as Jacob Epstein (1880–1959) and later Henry Moore (1898–1986) and Barbara Hepworth (1903–75). Gill not only used the British Museum to seek out new ways of representing the human form, but also visited specifically to research ancient and medieval styles and designs as models.

The short walk from his office (previously Edward Johnston's lodgings in Lincoln's Inn Fields) brought him to the galleries of the British Museum. As he began his trade as a letter-cutter, he went there and to the Victoria and Albert Museum to study Roman monumental inscriptions, to develop his own distinctive version of Roman lettering. He published a guide to his new letter forms as an appendix to Johnston's manual on lettering for craft workers in 1906: 'Beauty of Form may safely be left to a right use of the chisel, combined with a well-advised study of the best examples of Inscriptions: such as that on the

Design for George V's Great Seal, June 1914. Pencil drawing with pastel crayon, signed and dated by the artist (Royal Mint). 158 mm (diam.). Gill submitted this final design for the counterseal to the Royal Mint on 11 June 1914. He drew the king's mount with its back legs extended as when urinating, a typical subversive intervention. The design was approved, but with the outbreak of war with Germany on 4 August 1914 the new seal project was abandoned.

Funeral monument for Dasumia Soteris, Rome (now in British Museum), second century AD. Marble with red painted letters. Gill often visited the British Museum to study Roman letter forms and techniques.

Trajan Column and other Roman Inscriptions in the Victoria and Albert and British Museums ...' (see pages 9 and 21). He employed his distinctive new forms on his two inscriptions for the British Museum cut in 1911 (pages 22–3) and 1921 (page 24). In both cases the Museum was able to rely on Gill's reputation as the most competent letter-cutter of the time, allowing him to cut inscriptions directly onto the building in prominent positions.

When Gill was approached by the British Government to design a new Great Seal in 1913, he turned first to the British Museum to see what early medieval seals looked like and chose specific

Letter forms, comparing Gill's lettering as used in his 1911 inscription for the British Museum (pages 22–3) with the Roman prototypes he used (page 20).

models from the collection. Another public commission to design British silver coins prompted the same course of action. In both cases Gill deliberately chose models that enabled him to insult King George V, in whose name the seal and coins would be made, although in such a way that the officials did not recognize his subversive designs. Gill's designs met with approval, but, fortunately for the officials, circumstances prevented their use.

KING EDWARD THE S

THIS STONE

HIS MAJESTY KING I

ON THE TWENTY-SEVENTH DAY OF JUN

ANNO DNI

Foundation inscription for the King Edward VII building, British Museum, 1911, decorated with gilding.

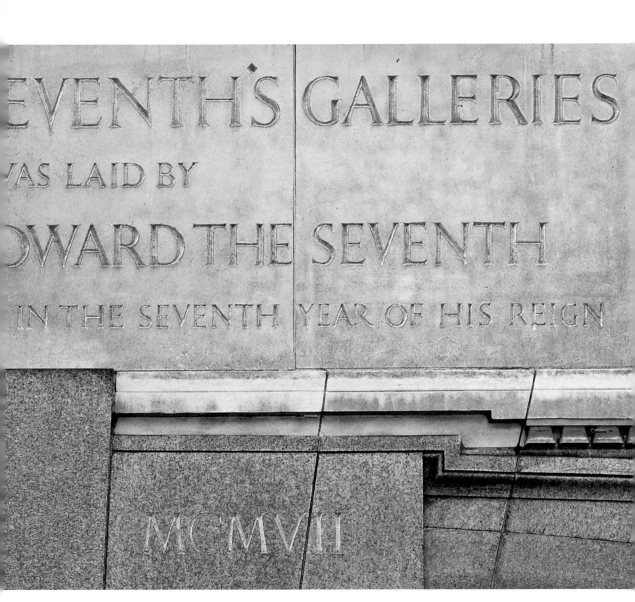

TO THE MEMORY OF THE MEN
WHO WENT FROM THIS MUSEUM
AND FOUGHT AND FELL IN THE WAR
1914~1918
IAN A.K.BURNETT: FRANK DERRETT
C.R.DUNT: W.J.EDEN: S.W.LITTLEJOHN
H.MICHIE: JOHN.F.T.NASH: E.PULLEN
J.M.SEELEY: R.SHEEHY: A.C.STEWART

THEY SHALL GROW NOT OLD
AS WE THAT ARE LEFT GROW OLD.
AGE SHALL NOT WEARY THEM
NOR THE YEARS CONDEMN.
AT THE GOING DOWN OF THE SUN
AND IN THE MORNING
WE WILL REMEMBER THEM.

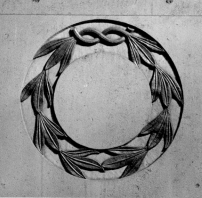

(*Left*) War memorial inscription, British Museum, 1921.
Gill cut the inscription, and his assistant Joseph Cribb carved the wreath from Gill's drawing.

(*Above*) Working drawing for the wreath on the British Museum's war memorial, 1921, pastel crayon on brown paper. 735 × 565 mm.

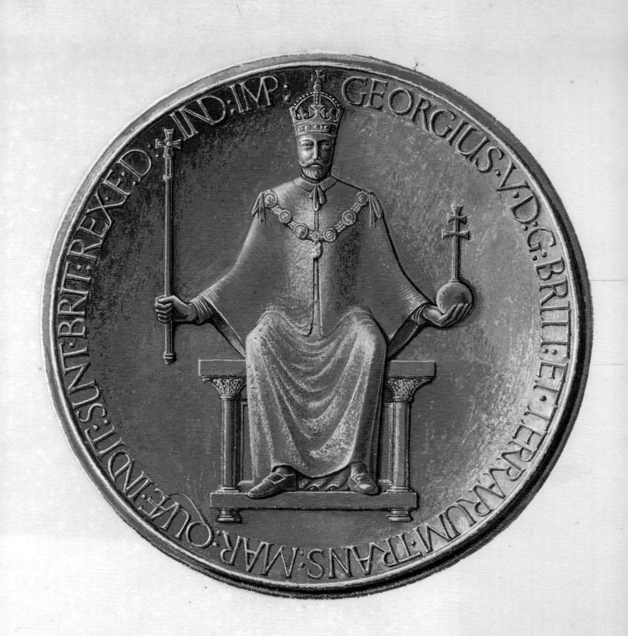

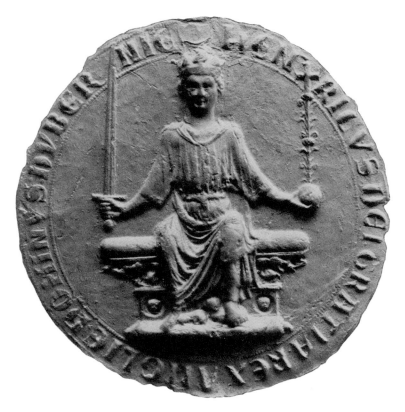

(*Above*) Henry III's Great Seal, 1230, illustration from A.B. Wyon and A. Wyon, *The Great Seals of England*, London, 1887.
Gill visited the British Museum to look at royal seals on 29 January 1913.

(*Left*) Design for George V's Great Seal, 21 February 1913. Pencil drawing with colour, signed and dated by the artist (William Andrews Clark Memorial Library, University of California, Los Angeles).
This was Gill's first attempt at designing the Great Seal, commissioned by the Lord Chancellor's Office. Gill wrote to his friend the artist William Rothenstein: 'Me do a portrait of Georgey on his throne! Did you ever see the Great Seal of Henry III – 1230? It's a bloody marvel.' (1 February 1913)

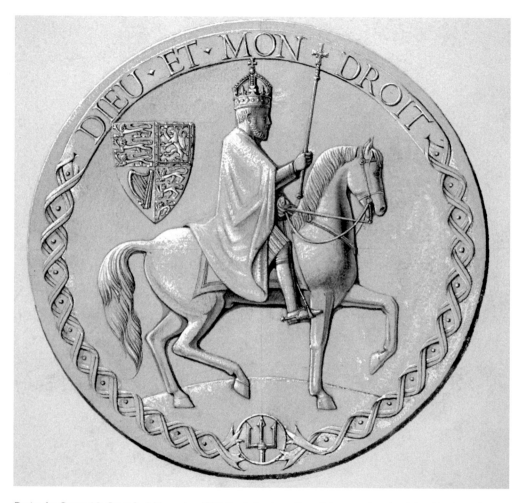

Design for George V's Great Seal, November 1913. Pencil drawing with pastel crayon, signed and dated by the artist (Royal Mint). 158 mm (diam.).

Gill submitted this second version of the counterseal to the Royal Mint on 11 November 1913. The posture of the horse, shield and figure reflects the treatment by Thomas Simon for Oliver Cromwell's Great Seal of 1655.

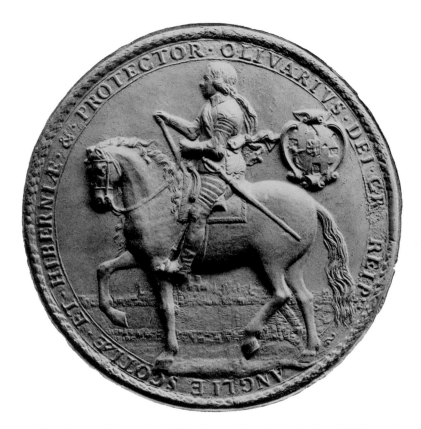

Oliver Cromwell's Great Seal, 1655, by Thomas Simon, illustration from A.B. Wyon and A. Wyon, *The Great Seals of England*, London, 1887.

Gill's choice of Cromwell's seal as a prototype for George V's was typical of his subversive attitude towards state authority.

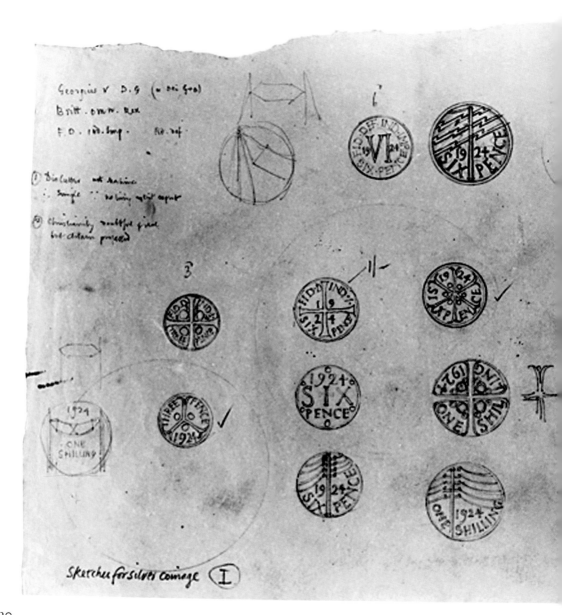

Sketches for silver coinage Ⅰ

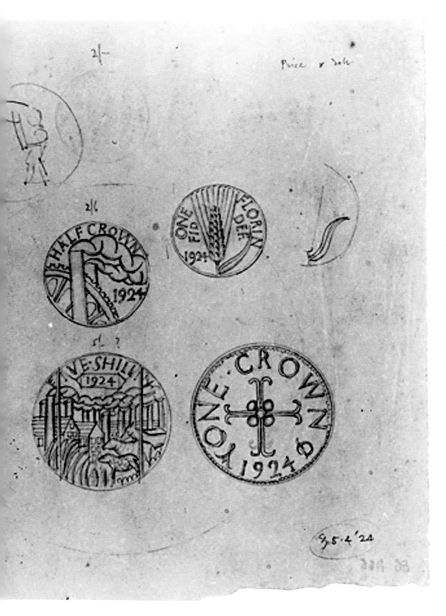

Designs for British silver coinage, 5 March 1924, initialled by the artist and mistakenly dated '5.4.24' (William Andrews Clark Memorial Library, University of California, Los Angeles).
305 x 178 mm.
These preliminary sketches followed an invitation from the Royal Mint to prepare drawings, as part of a competition, for new British silver coinage designs. On receiving the invitation Gill had written to his friend John O'Connor (*Letters*, page 173) that he wanted to decorate his coin designs with 'thinly veiled … symbols of money making' such as the three-spheres sign of pawnbrokers (see also page 101).

31

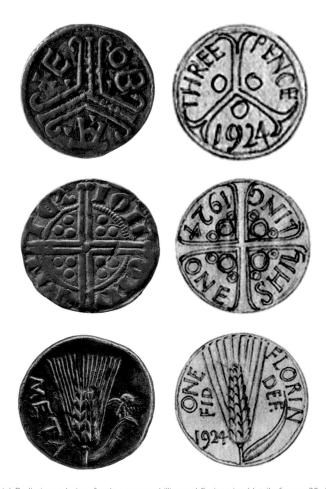

(*Right*) Preliminary designs for threepence, shilling and florin coins (detail of pages 30–1), with (*left*) the prototypes Gill found in the British Museum: English pennies (20 mm, 19 mm diam.), ninth and thirteenth centuries, and a Greek stater (20 mm diam.) fourth century BC, all silver. Gill made use of the triform motif from a penny of Coenwulf, king of Mercia (796–821), the heavy dots in the quarters of a cross from a penny of Henry III (1247–72), and the corn ear from a coin of the Greek city of Metapontum in southern Italy, c. 350 BC.

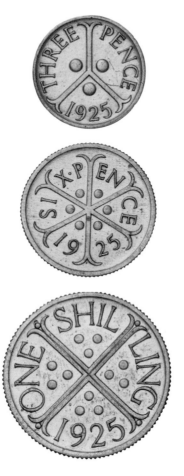

Pattern threepence, 16 mm diam., sixpence, 19 mm diam., and shilling, 25 mm diam., Royal Mint, 1925, silver, using Gill's designs (Royal Mint).
These pieces were made alongside those of three other artists to be shown to the king. Gill's designs were not selected, but his lettering was much admired.

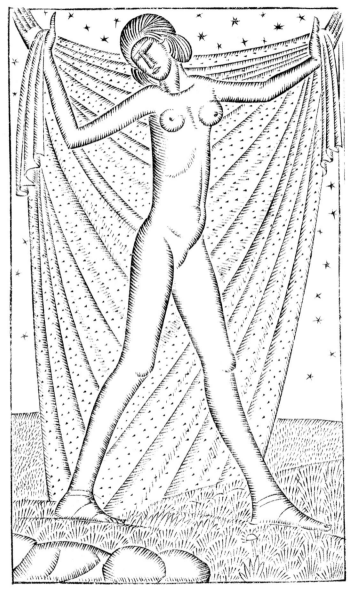

34

Eric G

CONNECTIONS

Gill's large family and his extensive personal and professional connections not only provided him with inspiration for his art and for the development of his ideas, but also gained him commissions. Gill was continually drawing, and this is most evident in the many portraits of his often-changing but always large circle. He drew his friends, family and colleagues, and created inscriptions, sculptures, engravings and drawings as gifts for them. From early in his career, he also used them as models for prints and sculptures. His sister Gladys and her husband Ernest Laughton, for example, modelled for the erotic carving *Ecstasy* in 1911 (pages 78, 79 and 98). Gladys was also the model for a low-relief carving (page 36).

Although he initially declined to work with the printer Robert Gibbings (1889–1958) because he was not a Catholic, in 1924 Gill was tempted to do so by the opportunity to illustrate a volume of poetry by his sister Enid Clay (1881–1972), being published by Gibbings at his Golden Cockerel Press. He soon became an intimate friend of Gibbings and his wife Moira, and worked with him on many more books (see pages 88–9). Gill's fascination with the naked form is well illustrated by his wood engravings for Enid's book and by his tender portraits of those around him, although the knowledge of his incest with

Naked Girl with Cloak, 1924. Wood engraving, signed by the artist. 97 × 57 mm. This illustration for his sister Enid Clay's book of poetry *Sonnets and Verses* (1925) was printed using the intaglio technique, with ink in the lines instead of on the surface of the block (see also page 39).

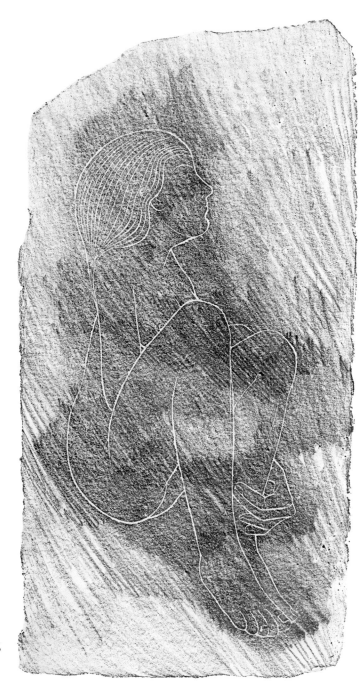

Gladys, 30 April 1913.
Rubbing of relief sculpture, based on a life drawing of Gill's sister Gladys.
754 × 368 mm.
The relief is now embedded in the wall of a house in Ditchling, Sussex. Gladys and her husband were also the models for Gill's large sculpture *Ecstasy* (see pages 78, 79 and 98).

his sisters and the sexual abuse of his daughters brings another, disturbing, dimension to some of these drawings (see page 77).

The image of Agnes Cribb nursing her daughter (page 44) is a a typical example of Gill using a member of his close circle of friends to explore one of his most frequent themes, the mother and child. His first sculptures on this theme, made in 1910, were praised by his friend the art critic Roger Fry (1866–1934) when writing to his fellow art critic Clive Bell (1881–1964): '... has anyone ever looked more directly at the real thing and seen its pathetic animalism as Gill has?'

Gill's many contacts in the Arts and Crafts movement and the Fabian Society continued to bring him commissions long after he had moved away from both. Through the Arts and Crafts movement he met the art historian Ananda Coomaraswamy (1887–1947) and was invited to write a preface for his album of ancient Indian sculpture, *Visvakarma* (London, 1914). Gill also received his first commission to illustrate a book for Coomaraswamy's *The Taking of the Toll* (London, 1915). Fabian Society links gained him a commission in 1923 from the *Daily Herald*, the official newspaper of the Labour Party, to design the medal and certificate for its Order of Industrial Heroism (pages 46 and 47). Gill, no longer sympathetic to his earlier socialist views, subverted the intention of the *Daily Herald* by making a religious medal, which surprisingly was accepted.

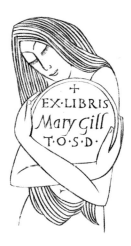

Bookplate for Mary Gill, 1926. Wood engraving, printed 1929. 60 × 30 mm. Eric Gill's wife (Ethel) Mary also became a member of the Third Order of St Dominic.

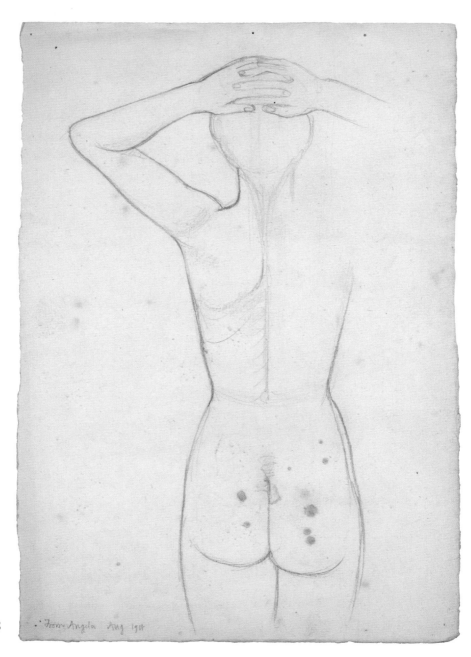

From Angela Aug 1911

tRicG

(*Left*) *From Angela*, August 1911. Drawing in pencil of Gill's youngest sister Angela, aged sixteen, dated by the artist (Hesburgh Libraries, University of Notre Dame, Indiana). 288 × 204 mm.

Gill's diaries and writings reveal his incestuous relationships with at least two of his sisters and his two eldest daughters.

(*Above*) *Naked Girl Lying on Grass*, 1924. Wood engraving, signed by the artist. 46 × 79 mm. This print was created as an illustration for Gill's sister Enid Clay's book of poetry *Sonnets and Verses* (1925), the first Golden Cockerel Press book for which he provided illustrations (see also page 34).

Elizabeth, 1924. Zinc engraving, signed by the artist. 175 × 126 mm.
Elizabeth (Betty), Gill's eldest daughter, married David, Douglas Pepler's son.

The Plait, 1922. Wood engraving, printed 1929. 164 x 96 mm.
This is a portrait of Petra, Gill's second daughter, who was then engaged to the painter David Jones, but later married Gill's assistant Denis Tegetmeier.

Joseph Briarfield, April 1918

(Above) Agnes, 226 × 133 mm, and *(left)* Joseph, 242 × 189 mm. 1915. Pencil drawings with colour, signed and dated by the artist.

(Herbert) Joseph Cribb was Gill's first apprentice (1907–13). He was the son of the cartographer Herbert William Cribb, an associate of Emery Walker, William Morris's printer. The portraits of Agnes Weller and Joseph Cribb were made as presents marking their engagement. Agnes had previously been a maid in the Gill household in Ditchling.

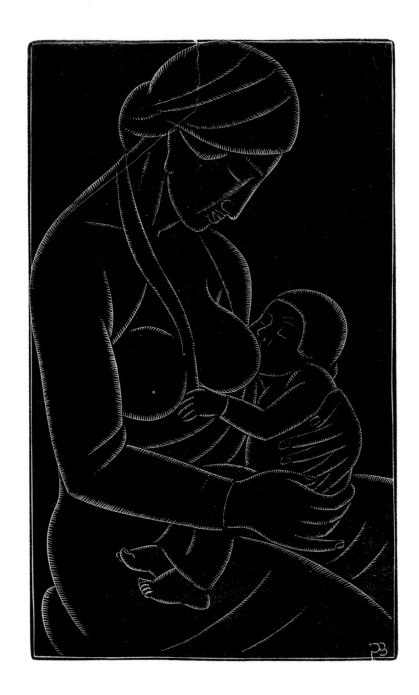

44

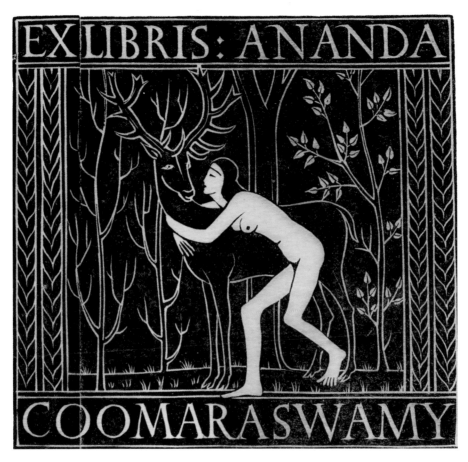

(*Above*) *Girl with Deer*, bookplate for A.K. Coomaraswamy, 1920. Wood engraving, printed 1929. 60 × 62 mm.
Gill was much influenced by the ideas of his friend Coomaraswamy, the pioneer historian of Indian art, who was briefly married to the Ditchling-based Arts and Crafts weaver Ethel Mairet.

(*Left*) *Mother and Child*, 1923. Wood engraving, printed 1929. 141 × 83 mm.
Gill sketched based this engraving on a sketch he made of Agnes Cribb nursing her third child (see also page 43).

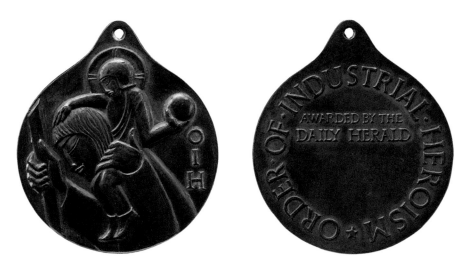

The *Daily Herald* Order of Industrial Heroism, 1923. Bronze medal. 40 mm (diam.).
Gill's commission to design this award was in part due to his earlier association with the Labour movement, through his membership of the Fabian Society. The dies were cut by the medallist George Friend from Gill's design (see also pages 17 and 66). Gill also had St Christopher medals cast from this design.

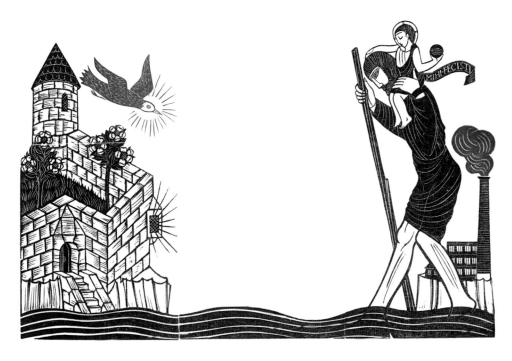

Order of Industrial Heroism, 1923. Wood engraving using five blocks for the certificate to accompany the medal, printed 1929. 127 × 191 mm.
The dove was replaced by a more appropriate red star when the certificates were printed.

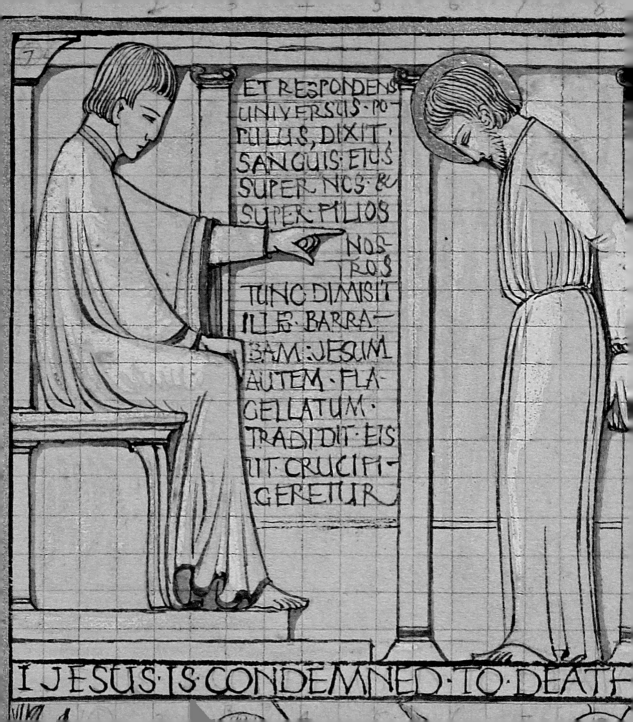

ET RESPONDENS
UNIVERSUS PO-
PULUS, DIXIT;
SANGUIS EIUS
SUPER NOS &
SUPER FILIOS
NOS-
TROS
TUNC DIMISIT
ILLIS BARRA-
BAM: JESUM
AUTEM. FLA-
GELLATUM.
TRADIDIT EIS
UT CRUCIFI-
GERETUR

I JESUS IS CONDEMNED TO DEATH

GOD

Gill's conversion to the Roman Catholic faith in February 1913 was one of the most important events in his career. In the following year he declared, 'The whole business of art is entirely without importance except in so far as it is conceived of and conducted as the material expression of religion.' (Gill's preface to Ananda Coomaraswamy's *Visvakarma*, London, 1914.) This transformation shaped his development and created a distinct public identity for Gill.

From July 1914 Gill came under the influence of a prominent Catholic preacher, Father Vincent McNabb (1868–1943) of the Dominican Order, who was a vociferous advocate of Distributism, a form of Catholic socialism known as the 'back-to-the-land' movement. Distributism was also publicly supported by Britain's two most distinguished Catholics, the writers G.K. Chesterton (1874–1936) and Hilaire Belloc (1870–1953). Father Vincent's ideas fitted well with Gill's own lifestyle, as in 1913 he had moved out of Ditchling village into a house with two acres of land, positioned between fields and Ditchling Common. The anti-capitalist and anti-industrialization message of Distributism also accorded with Gill's attachment to medieval ways of working derived from the Arts and Crafts movement, and encouraged him to write tracts reflecting the influence of the anti-industrial ideologies

'Station I, Jesus is Condemned to Death', detail of Gill's initial design for the Stations of the Cross for Westminster Cathedral, London, 1913 (page 56).

49

THE SPIRIT OF
FATHER FABER
APOSTLE OF LONDON

WITH A PREFACE BY
WILFRID MEYNELL

BURNS & OATES LTD.,
28 Orchard Street, London, W.
1914

Chalice and Host with Particles, 1914. Wood engraving on the cover of a booklet by Wilfred Meynell, published by the Catholic publisher Burns & Oates. 59 × 37 mm.
Soon after his conversion to Catholicism, Gill began to receive commissions from fellow believers.

within the Distributist movement, on 'Slavery and Freedom' and 'The Factory System and Christianity', in the magazine *The Game*, printed by Douglas Pepler in 1917.

Gill also fell under the influence of another Dominican priest, the thirteenth-century philosopher St Thomas Aquinas, and adopted one of his sayings as a motto: ID QUOD VISUM PLACET ('The beautiful thing is that which, being seen, pleases', *Beauty Looks after Herself*, 1933; see also page 93).

Conversion brought other new connections to Gill, as he received commissions to illustrate Catholic leaflets, and before the end of 1913 he had been invited to carve the fourteen Stations of the Cross for the newly built Westminster Cathedral (pages 56–7). This career-making commission kept Gill busy until 1918, employing a number of assistants on the job, including Joseph Cribb, who had now graduated from apprentice to assistant. Cribb also converted to Catholicism shortly after Gill.

Gill's conversion caused his relationship with Edward Johnston to cool, but brought to Ditchling many more Catholic craftsmen and artists. In July 1918, Gill and Pepler became members of the Third Order of St Dominic. With them in joining was Desmond Chute (1895–1962), a young Catholic artist who had attached himself to Gill. In 1920 the three of them, together with Joseph Cribb, who had also joined the Third Order, established a Catholic community of artists and craftsmen, the Guild of St Joseph and St Dominic. The constitution of the Guild stated that 'All work is ordained to God and should be Divine worship'.

Gill's version of Catholicism, founded in his radical views derived from Distributism, his disrespect for the authority of the Church and its hierarchy (see page 61) and his emphasis on the sexual relationship between the Church and Christ (see page 99), set him apart him from the Catholic establishment.

Eric Gill

The Trinity with Chalice, 1914. Wood engraving. 100 × 64 mm.
Gill made this design for Everard Meynell, a member of an influential Catholic family. When Gill decided to become a Catholic, he sought the advice of this family as the only Catholics he knew. The design refers to the Trinity and transubstantiation, two key aspects of the Catholic faith.

The Convert, 1925. Wood engraving. 90 × 67 mm.
Gill based this image on a scene of missionary life described in a letter
from his brother Romney, who had followed in their father's footsteps as a
minister, becoming a missionary in Papua New Guinea.

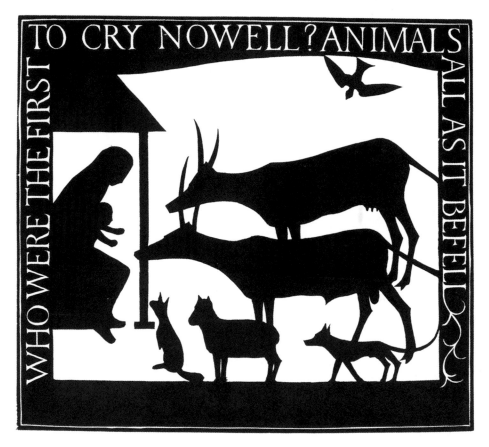

Animals All, 1916. Woodcut. Poster-sized design cut by Gill on a plank of wood. 375 x 412 mm. He also used the design for a Christmas card.

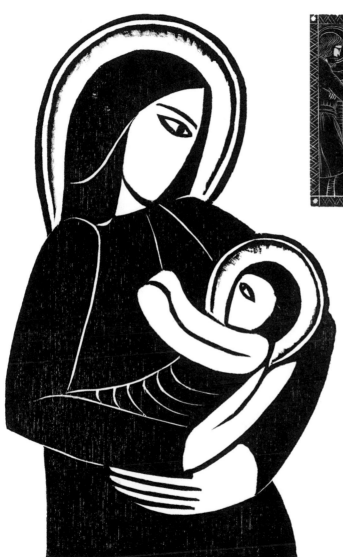

Eric Gill

(Above) *Nativity with Midwife, St Joseph Standing*, 1913. Wood engraving for Christmas card, reworking a design Gill had made in 1910 for his friend the art critic Roger Fry.
53 × 52 mm.

(Left) *Madonna and Child*, 1919. Woodcut for a poster to advertise an exhibition of Gill and Desmond Chute's 'Wood Cuts' at Chelsea Book Club, 1919, printed by St Dominic's Press, Ditchling.
166 × 99 mm.
This woodcut was also reprinted in Eric Gill's *Wood Engravings*, 1924 (see page 70).

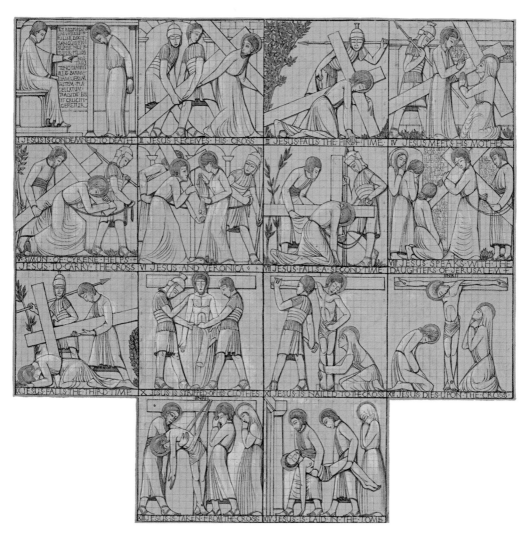

Preparatory drawing for Westminster Cathedral Stations of the
Cross, squared up for enlargement. Ink and colour drawing with
gilding, 1913. 275 × 241 mm.
This was Gill's first large public commission for sculpture.

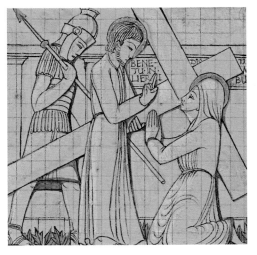

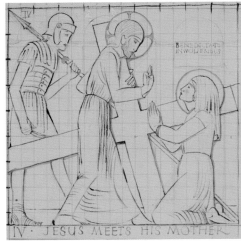

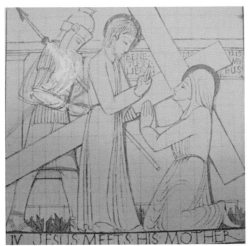

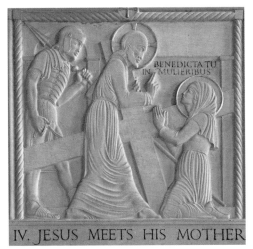

Station IV, Jesus Meets His Mother, design stages.

(Top left) Detail of original drawing, 1913 (page 56).

(Bottom left) Workshop photograph marked with pencil and white paint (Hesburgh Libraries, University of Notre Dame, Indiana). 117 × 116 mm.
Gill used photographs of his 1913 drawing to develop the composition.

(Top right) Working drawing dated 14 February 1916. 186 × 164 mm.

(Bottom right) The finished sculpture in Westminster Cathedral, 1916. 680 mm × 680 mm.

57

I
JESUS
IS CONDEMNED TO DEATH

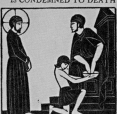

Adoramus te, Christe, et benedicimus tibi
Quia per sanctam Crucem tuam redemisti
mundum.

Jesus, mocked, beaten and spat upon, is taken
before Pilate and condemned to the death of
the Cross.

O CHRIST we hear again the cry
Of "Crucify him—crucify."
We sit with Pilate on the throne,
And, with the crowd, Thy Name disown,
Condemning Thee to death in fear
That, having ears, all men might hear,
And, having eyes, all men should see
The Christ in one from Galilee.

Pater Noster. Ave Maria. Gloria Patri.

II
JESUS
RECEIVES HIS CROSS

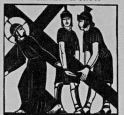

Adoramus te, Christe, et benidicimus tibi
Quia per sanctam Crucem tuam redemisti
mundum.

Jesus is led out of the Judgement hall. The
Cross, upon which at Calvary His body is
to be nailed, is laid upon His shoulders.

The dolorous way Thou dost begin.
The way that we have set Thee in
Is paved, as by our sins, with stones
Which cut Thy feet and ache Thy bones.
We help the carpenters to make
The cross the soldiers bid Thee take,
And while our wilful pride prevails
We help the blacksmiths point the nails.

Pater Noster. Ave Maria. Gloria Patri.

III
JESUS
FALLS THE FIRST TIME

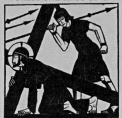

Adoramus te, Christe, et benedicimus tibi
Quia per sanctam Crucem tuam redemisti
mundum.

Jesus, bowed down under the weight of the
Cross, sets forth on the way. He stumbles
and falls.

The Sinless bears the sins of all;
Our heavy sins cause Thee to fall.
If Thou shouldst be the Christ divine
Give to us an outward sign,
Let Angels raise Thee up, obey
Thy word, and we will kneel and pray!
But in Thy fall we do not see
The sign of our iniquity.

Pater Noster. Ave Maria. Gloria Patri.

IV
JESUS
MEETS HIS MOTHER

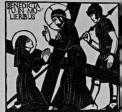

Adoramus te, Christe, et benedicimus tibi
Quia per sanctam Crucem tuam redemisti
mundum.

Seized by the guards Jesus rises from the
ground. The journey is continued. Looking
round Jesus sees His Mother.

Thy Mother kneeling Thou dost bless
She shareth Thy cup's bitterness,
She sees Her Son whom others scorn,
Her Baby in the Manger born,
Needing Her love and care as when
God's coming was good news to men.
We look,—and yet we do not see
She shareth in Thy victory.

Pater Noster. Ave Maria. Gloria Pe

VIII
JESUS SPEAKS TO
THE DAUGHTERS OF JERUSALEM

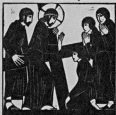

Adoramus te, Christe, et benedicimus tibi
Quia per sanctam Crucem tuam redemisti
mundum

Women bewail His suffering. Jesus says to
them "Daughters of Jerusalem, weep not over
me, weep for yourselves and for your children."

Now Thou dost rise and turn to bless
The women who are comfortless;
Though they have come to mourn the dead
These mourners shall be comforted.
Warned of the price of sin, they choose
The gift of God they will not lose ;
While we, who will not hear and learn,
Sin's wages choose and death do earn.

Pater Noster. Ave Maria. Gloria Patri.

IX
JESUS
FALLS THE THIRD TIME

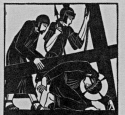

Adoramus te, Christe, et benedicimus tibi
Quia per sanctam Crucem tuam redemisti
mundum.

Jesus approaches Calvary where He is to be
crucified; bruised, bleeding and exhausted, He
falls for the third time.

Thy way ends, Golgotha is here,
If Thou art Christ let God appear !
Thus cry we in our unbelief,
O Man of Sorrows, known to grief;
And Thou dost fall to show the way
God's love encompasseth our clay.
The mighty love Thou dost confess
We sneer at as Thy feebleness!

Pater Noster. Ave Maria. Gloria Patri.

X
JESUS IS STRIPPED
AND GIVEN GALL TO DRINK

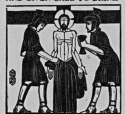

Adoramus te, Christe, et benedicimus tibi
Quia per sanctam Crucem tuam redemisti
mundum.

Jesus is arrived at Calvary, the soldiers prepare
Him for the Cross offering a cup of gall and
stripping Him of His clothes.

Thy Cross is planted in the earth,
We bargain for Thy garment's worth,
And with the soldiers throw the dice
As we prepare The Sacrifice.
The gall, which would Death's sharpness [break,
The gift of sin, Thou wilt not take, [break,
For Death and Sin Thou dost defeat
To make Thy gift of Life complete.

Pater Noster. Ave Maria. Gloria Patri.

XI
JESUS
IS NAILED TO THE CROSS

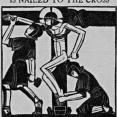

Adoramus te, Christe, et benedicimus tibi
Quia per sanctam Crucem tuam redemisti
mundum.

The Cross is fixed in the ground. Jesus is lifted
up by the soldiers and nailed to the Cross by
His Hands and Feet.

And now in anger we begin
This final tragedy of sin;
We nail Thee to Thy throne, O King,
A crown of thorns for Thy crowning,
And a spear thrust Thy body through:
Truly, we know not what we do.
Thou knowest, yet dost Thou forgive
Thy murderers that they may live.

Pater Noster. Ave Maria. Gloria Patri

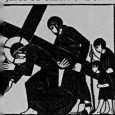

V
SIMON OF CYRENE HELPS
JESUS TO CARRY THE CROSS

Adoramus te, Christe, et benedicimus tibi
Quia per sanctam Crucem tuam redemisti
mundum.

His human strength fails. The soldiers seize
a stranger, Simon of Cyrene, and compel
him to carry the cross with Jesus.

Fearing Thy strength will not suffice
To meet in full the sacrifice,
We seize a countryman to share
The burden we would have Thee bear.
Thus Simon willing to obey
Followeth with Thee in Thy way.
[His sons shall glory in Thy Name;
Will ours, O Christ, record our shame?]

Pater Noster. *Ave Maria.* *Gloria Patri.*

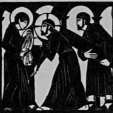

VI
JESUS
MEETS VERONICA

Adoramus te, Christe, et benedicimus tibi
Quia per sanctam Crucem tuam redemisti
mundum.

A woman comes through the crowd to minister
to Jesus. She wipes His face with a napkin; the
image of the Holy Face remains upon the linen.

A woman sees Thy suffering
And doth her gift of pity bring;
She holds a napkin to Thy face,
The clean cool cloth Thou dost embrace.
As Thy true image is impressed
Veronica is named and blessed;
That in all things the faithful can
Discern Thy likeness, Son of Man.

Pater Noster. *Ave Maria.* *Gloria Patri.*

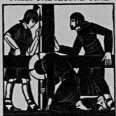

VII
JESUS
FALLS THE SECOND TIME

Adoramus te, Christe, et benedicimus tibi
Quia per sanctam Crucem tuam redemisti
mundum.

Though assisted by Simon of Cyrene the pain
and burden is too great and Jesus falls to the
ground a second time.

We see Thy body bruised and bent
Fearfully we would repent
Of having set Barabbas free :—
We blame the mob's inconstancy,
Its babel in the Judgement hall,
And Simon now that Thou dost fall.
Against Thy silence we complain
O Word of God whom we disdain.

Pater Noster. *Ave Maria.* *Gloria Patri.*

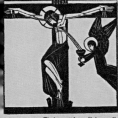

XII
JESUS
DIES UPON THE CROSS

Adoramus te, Christe, et benedicimus tibi
Quia per sanctam Crucem tuam redemisti
mundum.

For three hours Jesus hangs upon the Cross,
two thieves hanging on either side of Him;
then crying "It is finished" He dies.

Water and blood flowing from thy side
Canst save Thyself, O Crucified?
We question: the Centurion cries
IT IS THE SON OF GOD WHO DIES.
The darkness comes, the veil is rent,
God's Love upon the Cross is spent—
And still we doubt, can these things be,
Can God come out of Galilee?

Pater Noster. *Ave Maria.* *Gloria Patri.*

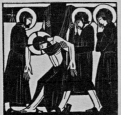

XIII
THE BODY OF JESUS IS
TAKEN DOWN FROM THE CROSS

Adoramus te, Christe, et benedicimus tibi
Quia per sanctam Crucem tuam redemisti
mundum.

The sightseers have gone. Joseph of Arimathea
and Nicodemus come to take down the body of
Jesus which Mary receives in Her arms.

The Son of Man has hung and bled—
How can man live if God be dead?
We dare not look upon that One,—
In panic from His cross we run.
But they who love Thee take Thee down,
Draw out the nails, remove the crown.
Myrrh, aloes and a shroud they bring
To clothe Thee for Thy burying.

Pater Noster. *Ave Maria.* *Gloria Patri.*

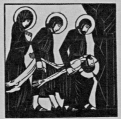

XIV
THE BODY OF JESUS
IS LAID IN THE TOMB

Adoramus te, Christe, et benedicimus tibi
Quia per sanctam Crucem tuam redemisti
mundum.

The body of Jesus is carried to a newly hewn
tomb in the rock, the door is sealed, a guard is set.

O MARY art Thou not dismayed
As His Body in the grave is laid,
As the Body we have marred
Is subject to the soldiers' guard?
"The seed has fallen and has died
"That God's good fruit be multiplied,
"The roots of God shoot through the earth,
"This tomb shall be His gate of birth.
"Accept, man, Him thou hast denied—
"As God in Me was magnified
"In thee may He be glorified."

Pater Noster. *Ave Maria.* *Gloria Patri.*

The Stations of the Cross,
1917. Wood engravings
printed by St Dominic's
Press, Ditchling, for
devotional use.
443 × 568 mm (*sheet*).
These engravings were
adapted from Gill's 1913
drawing (page 56).

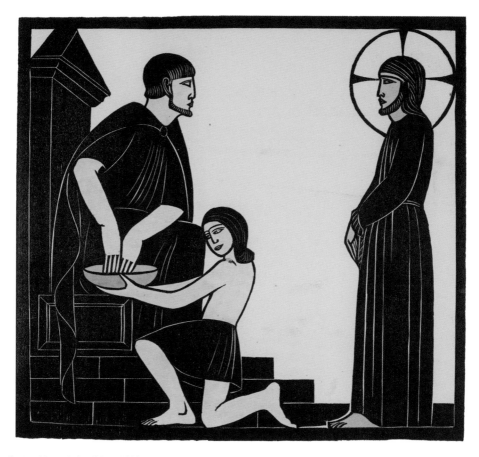

Station I, Jesus before Pilate, 1928. Hand-coloured woodcut, printed by Douglas Cleverdon, Bristol. 295 × 315 mm.

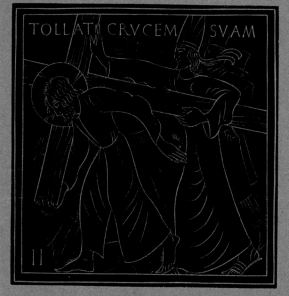

SOCIAL JUSTICE
& THE STATIONS
OF THE CROSS, BY

TOLLAT CRVCEM SVAM

ERIC GILL, T.O.S.D.

LONDON: JAMES CLARKE &
CO LTD ONE SHILLING NET

The Way of the Cross, 1939.
Wood engraving on the
cover of Gill's tract *Social
Justice and the Stations of
the Cross*, 1939 (private
collection). 168 × 108 mm.
Gill used this image of
the second Station of the
Cross to attack formal
religion by showing
a bishop, helped by
businessmen, placing the
cross on Christ's back.

ABCDEFGH
IJKLMNO
PQRSTU
VWX
YZ
&

PRINT

Gill's engagement with print began in 1905 when he was commissioned by Count Harry Kessler (1868–1937) to design title pages for his German publishing house Insel Verlag. This work was passed to him by his mentor Edward Johnston. Johnston also provided Gill with his first opportunity to publish, giving him an appendix in his book *Writing & Illuminating & Lettering*, 1906. This gave him a taste for book work which he was able to satisfy when his friend Douglas (Hilary) Pepler invited him to illustrate his book *The Devil's Devices* in 1915 (see pages 68 and 100).

Gill met Pepler, a former social worker and writer on social reform, early in 1905 in the Arts and Crafts community in Hammersmith, where Johnston also lived. Johnston, Pepler and Gill soon formed a close relationship, discussing art, politics and religion, often until the early hours. The influence on Gill of this relationship was evident not just in his ideas, but also in his art and artistic production. Hammersmith was also home to Thomas Cobden-Sanderson (1840–1922) and Emery Walker (1851–1933), the two printers most closely associated with the founding father of the Arts and Crafts movement, William Morris (1834–96).

In 1915 the Catholic printer Gerard Meynell, also a Hammersmith resident, printed Pepler's *Devil's Devices* with

An Alphabet, 1918.
Wood engraving designed
for St Dominic's Press.
292 × 322 mm.

Gill's illustrations. This publication is thought to be one of the first books to contain modern wood engravings. The book was published by Pepler through the Hampshire House Workshops he had set up in 1914 to provide employment for Belgian refugee craft workers fleeing the outbreak of World War I. Pepler also commissioned Gill to design an emblem

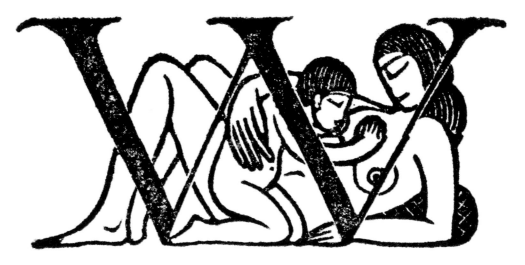

and seal for the workshops and the associated bakery, and to contribute works to an exhibition in aid of the refugees (see pages 66, 67 and 69).

Initial W with Woman and Child, 1916. Wood engraving, reprinted 1924 (detail of page 70).

After Gill moved to Ditchling in 1907, Johnston followed in 1913 and Pepler in 1915. Pepler acquired a hundred-year-old Stanhope press and together they started a magazine, *The Game*, to publish their writings and art. In 1916 Pepler formally established his business as the St Dominic's Press. On the

second anniversary of its establishment, Pepler wrote a poem recording their collaboration: 'We printed large and black and clearly,/ Way Ho, a-printing we will go./ We printed quite as well – or nearly/ As the old printers printed printing long ago./ The sculptor did the very best he could/ Way Ho, a-graving we will go./ To grave us pretty pictures upon the wood/ As gravers graved graving long ago.'

Pepler's press gave Gill the impetus to start creating wood engravings in earnest, and he produced about 250 blocks before falling out with Pepler in 1924. The pair used the press to disseminate their political and religious ideas, publishing some of Gill's best-known essays such as 'Essential Perfection' (1918), 'Sculpture' (1918) and 'War Memorial' (1923) with illustrations showing the development of Gill's skill and understanding of this art. The close collaboration between the two men enabled Gill to understand the correlation between written word and accompanying illustration. The experience gained with Pepler also gave Gill insight into typography, which enabled him to create new fonts after he left Ditchling.

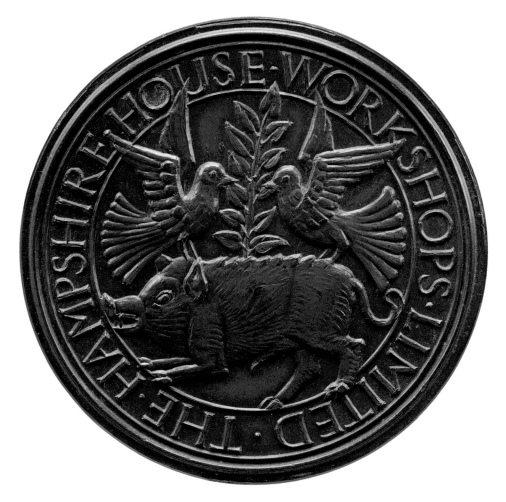

(*Above*) Hampshire House Workshops seal, *c.* 1915, copper counterseal. 58mm (diam.).
The steel seal die was cut by George Friend from Gill's design (see also pages 17 and 46).

(*Right*) Hog and Wheatsheaf, 1915. Wood engraving, design for the paper bags and posters of the Hampshire House Bakery, Hammersmith. 135 x 135 mm.

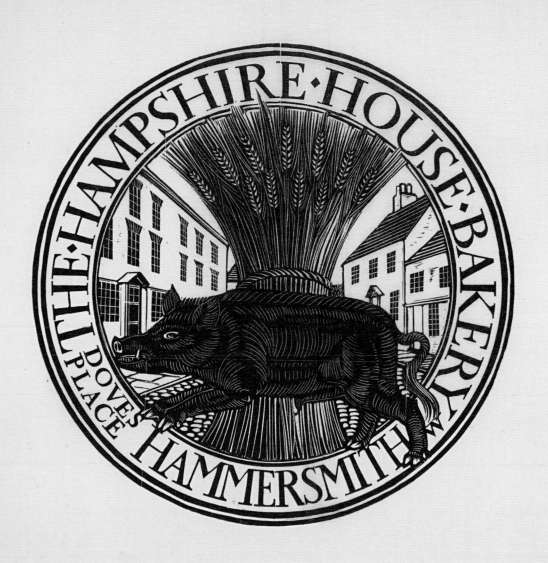

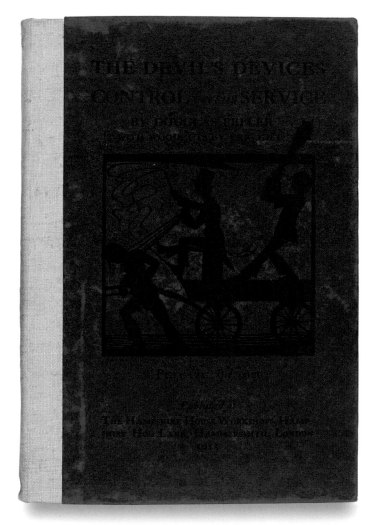

(*Left*) *Dumb Driven Cattle*, 1915. Wood engraving, design for the cover of Douglas Pepler's book *The Devil's Devices*, 1915 (see also page 100).
190 x 131 mm.
This book marked the beginning of almost ten years of collaboration in print between Gill and Pepler. Douglas Pepler changed his name to Hilary on his conversion to Catholicism in 1917.

(*Right*) *The Slaughter of the Innocents*, 1914. Wood engraving for a brochure for an art exhibition in aid of Belgian refugees fleeing the German invasion.
60 x 49 mm.
Gill and Cribb offered works for sale in the exhibition. Pepler set up the Hampshire House Workshops to provide employment for Belgian refugee craftsmen.

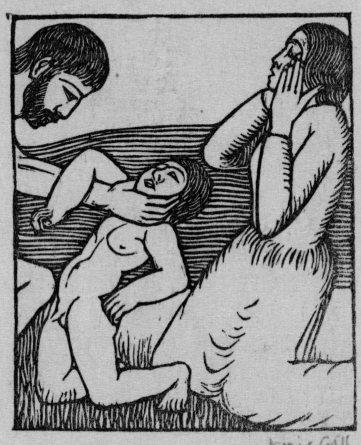

Wood-engravings

Being a selection of *ERIC GILL'S* engravings on wood. The first (Virgin and Child) is a wood cut, that is cut with a knife on the long grain of the wood instead of with a graver on the "end" grain. This was cut for a Poster.

Printed and Published at S. Dominic's Press, Ditchling, Sussex

A.D. 1924

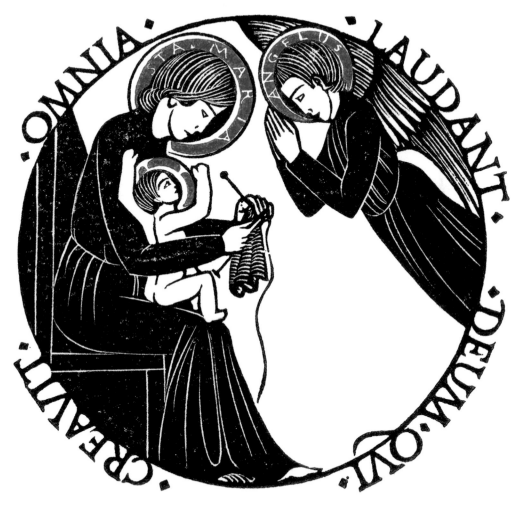

OMNIA · LAUDANT · DEUM · QUI · CREAVIT ·

STA · MARIA

ANGELUS

(*Left*) *Initial W with Woman and Child*, 1916, and *SDP and Cross*, 1918 (the emblem of St Dominic's Press). Wood engravings on the title page of Eric Gill's *Wood Engravings*, St Dominic's Press, 1924 (see pages 55 and 64). 312 × 254 mm.

(*Above*) *The Madonna and Child with an Angel: Madonna Knitting*, 1916. Wood engraving for Pepler's rhyme sheet *Mary Sat A-Working*, St Dominic's Press, Ditchling, 1916. 62 × 63 mm.

Adeste Fideles (O Come, All Ye Faithful), 1916. Wood engraving for booklet *Adeste Fideles, a Christmas Hymn*, St Dominic's Press, Ditchling, 1916. 51 × 51 mm.

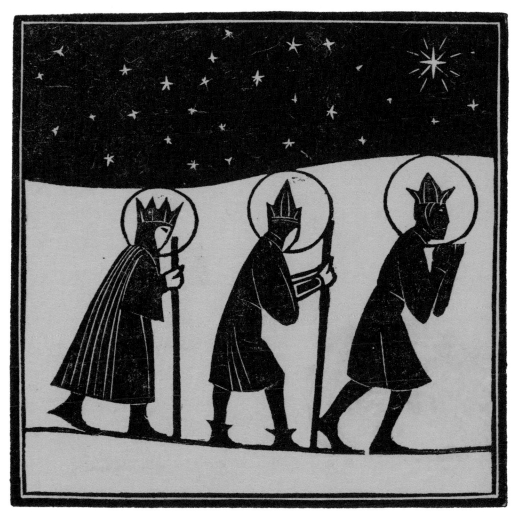

Three Kings, 1916. Wood engraving for booklet *Adeste Fideles, a Christmas Hymn*, St Dominic's Press, Ditchling, 1916. 50 × 51 mm.

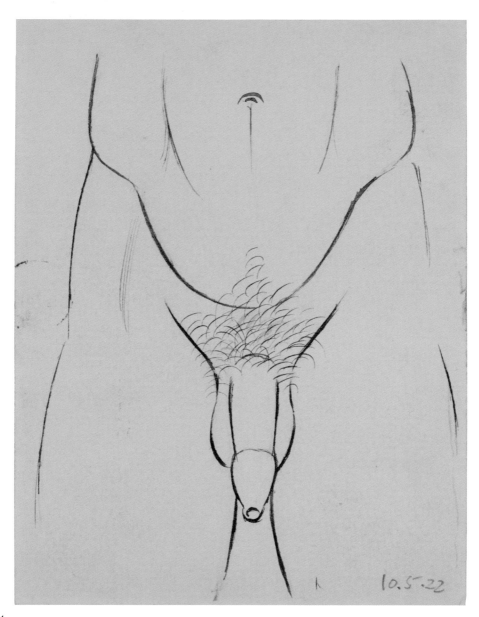

10.5.22

THE BODY

Sex was a central force in many aspects of Gill's private and public art, his writings and his daily life. His obsession with sex has increasingly dominated the viewing and discussion of his art, and is often contrasted with his Catholic faith.

In his essay *Clothing without Cloth* (1931), Gill wrote in praise of the human body: 'Another reason for nakedness is PLEASURE pure and simple. For the beautiful thing is that which being seen pleases, and nothing is more pleasing when seen than the nude human body clothed in its variously tinted skin, decked out with its four or five bushes of hair, modelled more subtly than is any other creature for movement and strength, from which shines out the unique radiance of rationality.' Gill's drawings, sculptures and engravings seem at times to be simply a documentation of sexual organs and activities, but in this essay he attempted to create a rationale for nakedness by discussing art, clothing traditions and morality. He argued that 'clothes are primarily for dignity and adornment': it is only in the naked form that all men are equal and beautiful in the eyes of God.

For Gill, in his art and in life, the most beautiful image of man and woman was not simply naked, but also in the act of sexual intercourse. In his sculptures, prints and drawings, Gill explored the connection between bodies, reflecting

Self-portrait dated 10 May 1922. Pen drawing. 360 × 250 mm (*sheet*).

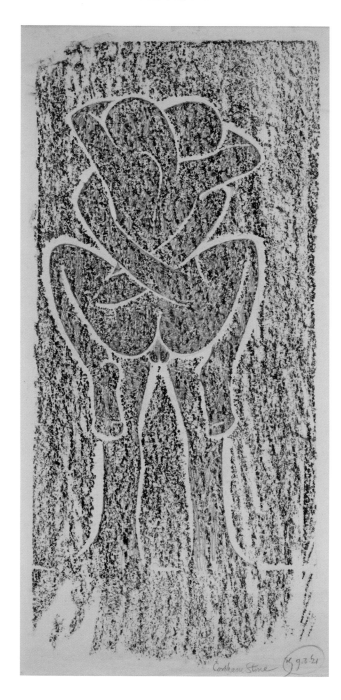

Man and woman having sex,
9 March 1921. Rubbing of
low relief in Corsham stone.
350 x 195 mm.
The original is now lost.

the influence of Indian art in the exaggerated sexuality of the human body and the frequently explicit sexual organs: 'One thing only in the whole world is more absurd than the convention of the fig leaf, and that is the pretence that sex is not uniquely significant.'

Gill made intimate connections between his faith and his ideas on sex and the body. Although the sacred and the profane in Gill's art are often placed in opposition by commentators, Gill in fact closely aligned these two aspects in his mind and in his work (see pages 99–101). 'If naked bodies can arouse a hell-hunger of lust, they can and do kindle a hunger for Heaven.' (*Drawings from Life*, 1940.)

Young man with erection, undated, rubbing of low relief sculpture ('stone destroyed E.G.'). 245 × 375 mm. Gill's album of erotic drawings in the British Museum contains many explicit images of himself and of his male friends and colleagues. This image seems to have been inspired by the representation of a satyr on an ancient Greek vase in the British Museum.

The most important and controversial part of the British Museum Gill collection is made up of his 148 life drawings of sexual anatomy and sexual intimacy, drawn throughout Gill's life, using family, friends, assistants and himself as subjects. 'The members of your own household and your friends and relations are the best models ... it is among the things you love that you must choose the things to carve – or to draw, or to paint' (*Sculpture and the Living Model*, 1932). When understood in the light of the revelations in his diaries of incest and sexual predation however, the British Museum collection shows an obsession with sex reaching far beyond anatomy, religion and art to the humorous, salacious and often pornographic. Gill gave these 'studies of parts' to his brother Cecil, a medical doctor, asking him to offer them as anatomical references to the Royal College of Surgeons, who refused them.

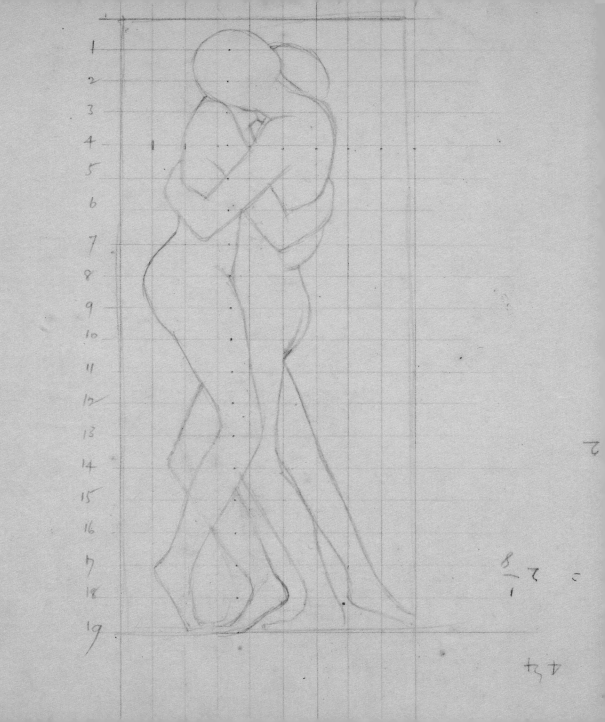

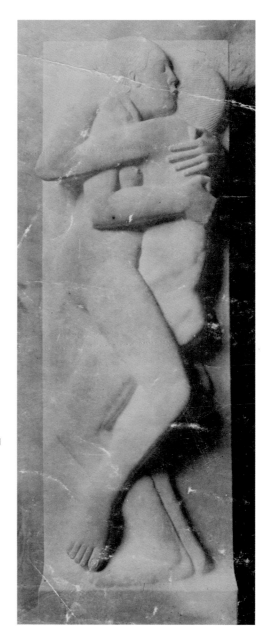

(*Left*) Man and woman having sex standing up, 1910. Pencil drawing, squared for enlargement, unused preliminary drawing for his sculpture *Ecstasy* (see pages 79 and 98). 244 × 147 mm.

(*Right*) *Ecstasy*, 1910–11. Workshop photograph of relief sculpture in Portland stone (private collection). Gill's diaries suggest that his sister Gladys and her husband posed for this sculpture, which he initially referred to as *Fucking* or *They Large*. Joseph Cribb, who spent 47 hours helping Gill with the carving, preserved this photograph (see also page 98).

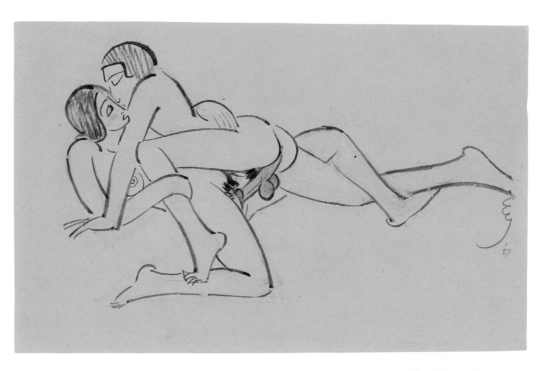

(*Above*) Man and woman
having sex, 1927. Ink
drawing with colour.
245 × 375 mm (*sheet*).

(*Right*) Man and woman
having sex, 1 March 1930.
Pencil drawing with ink
wash and colour (see also
page 104).
245 × 375 mm (*sheet*).

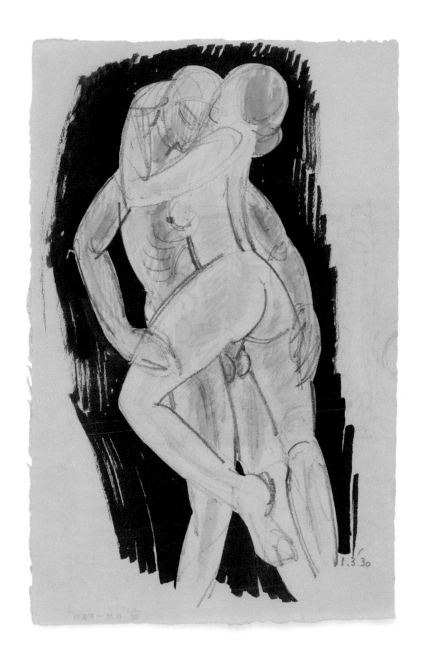

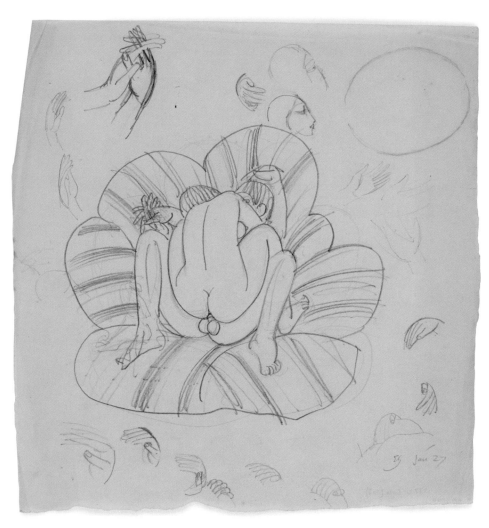

Man and woman having sex on cushions, January 1927, pencil drawing. 245 × 375 mm (*sheet*).
Another version of this drawing has the title *Lot's Daughter* (18 December 1926; Yorke 1982, page 112).

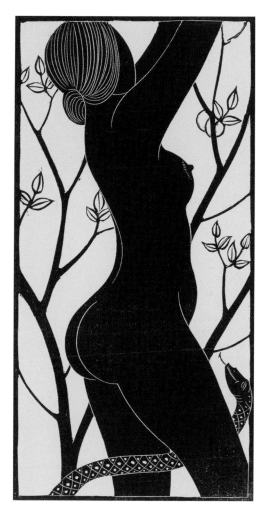

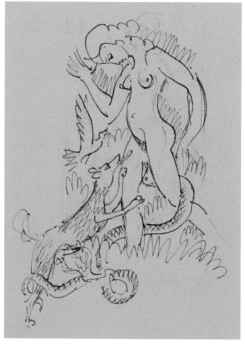

Eve, 1926. Wood engraving. 239 × 119 mm.
This ostensibly religious image has other meanings, as can be seen from Gill's sketches for the design (see also page 13).

Eve with animals, undated, pen drawing. 245 × 375 mm (*sheet*).
This is one of Gill's sketches on the theme of Eve, making the phallic symbolism of the serpent explicit.

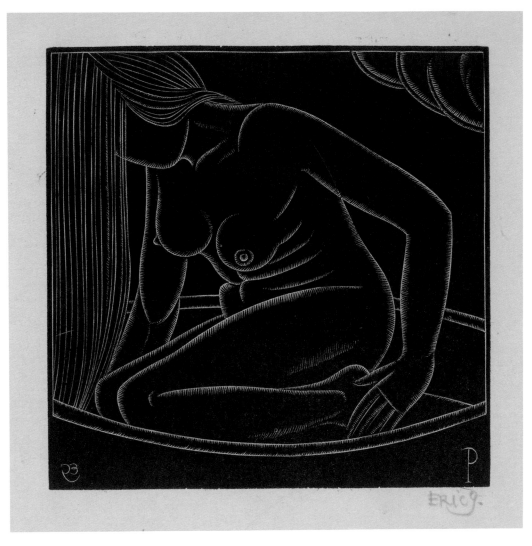

Girl in Bath II, 1923. Wood engraving after life drawing of Gill's daughter Petra, signed by the artist. 106 × 106 mm.

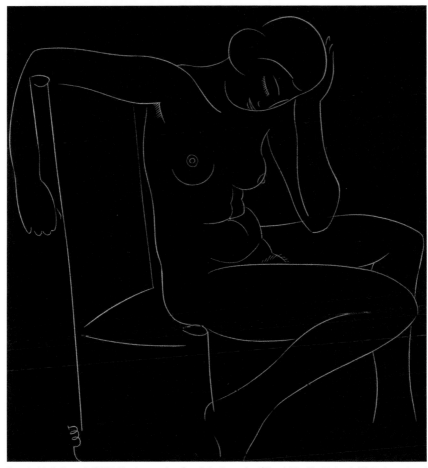

Female Nude Seated, 1937. Wood engraving, fourth in the series Gill published in his book *25 Nudes*, printed by Gill and Hague and published by Dent & Sons Ltd, London, 1938 (Ditchling Museum). 229 × 140 mm. Most of these nudes were based on life drawings of Gill's mistresses Beatrice Warde and Daisy Hawkins.

THE BOOK

After Gill left Ditchling in 1924, his break with Pepler did not end his involvement with books, but instead opened up new opportunities for him both to promulgate his political and social ideas and to publish his engravings. From 1924 until his death in 1940, Gill wrote thirty-eight books and tracts, and illustrated another twenty-eight.

Gill's engagement with book production also led him into a new area of creativity. After his attempts at designing wood engraving alphabets for Pepler's St Dominic's Press and for the German publisher Insel Verlag, in 1925 Gill turned his attention to creating a new font called Perpetua, based on Roman lettering. He developed the font with Stanley Morison (1889–1969) of the Monotype Corporation. The initial letter forms were made in 1926, but not put into production until 1928. Gill also produced his most successful font, Gill Sans, with Morison in the same year. His success in this new enterprise led to the creation of eleven typefaces in total: Perpetua (1925–8), Gill Sans (1927–8), Felicity (1929), Perpetua Greek (1929), Solus (1929), Golden Cockerel (1929–30), Joanna (1930), Aries (1932), Floriated Capitals (1935), Bunyan (1934) and Jubilee (1934). The clarity of line and letter developed while cutting letters in stone ensured the success of these new fonts.

Tree and Burin, 1920. Wood engraving with colour, printed from three blocks. 230 × 184 mm.
Gill made this design for use on posters and leaflets for the newly formed Society of Wood Engravers.

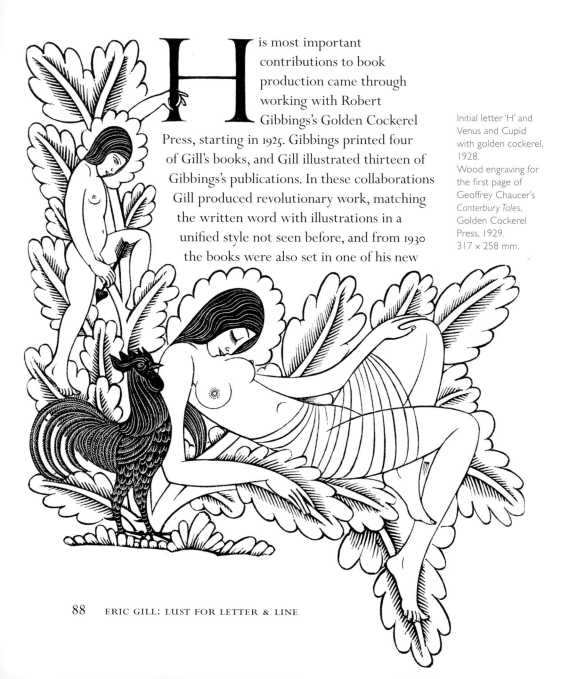

His most important contributions to book production came through working with Robert Gibbings's Golden Cockerel Press, starting in 1925. Gibbings printed four of Gill's books, and Gill illustrated thirteen of Gibbings's publications. In these collaborations Gill produced revolutionary work, matching the written word with illustrations in a unified style not seen before, and from 1930 the books were also set in one of his new

Initial letter 'H' and Venus and Cupid with golden cockerel, 1928.
Wood engraving for the first page of Geoffrey Chaucer's *Canterbury Tales*, Golden Cockerel Press, 1929.
317 × 258 mm.

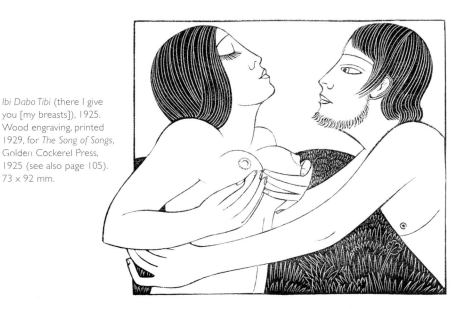

Ibi Dabo Tibi (there I give you [my breasts]), 1925. Wood engraving, printed 1929, for *The Song of Songs*, Golden Cockerel Press, 1925 (see also page 105). 73 × 92 mm.

fonts. The simplicity and clarity of many of their title-page designs belic the complex working process that was the result of an incredible closeness of ideas between the two men. With Gibbings he created publications then considered to be in the avant-garde of book design. Gill was able to work in this way largely due to what he learned during his early collaborations with Johnston, Kessler and Pepler, but also due to his ongoing connections with other avant-garde wood engravers through the Society of Wood Engravers.

Gill was one of the founder members of the society in 1920, together with the artists Robert Gibbings, Philip Hagreen (1890–1988), Noel Rooke (1881–1953), Sydney Lee (1886–1949), Edward Gordon Craig (1872–1966), Paul Nash (1889–1946),

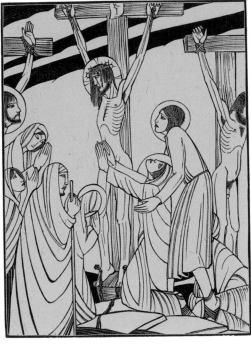

The Crucifixion, 1926. Wood engraving for *Passio Domini Nostri Jesu Christi*, Golden Cockerel Press, 1926. 156 × 114 mm.

Lucien Pissarro (1863–1944), Gwen Raverat (1885–1957) and Edward O'Rourke Dickey (1894–1977). Many of its members sought to revive hand engraving and hand printing traditions.

In 1931 Gill set up his own printing press with his son-in-law René Hague, next to the stone-carving workshop at their home in Pigotts, Buckinghamshire. Hague and Gill printed sixteen of Gill's own books and tracts, some illustrated by another son-in-law, Denis Tegetmeier. Gill also illustrated six other Hague and Gill books by other authors. Many of these books were printed using Gill's elegant Joanna font.

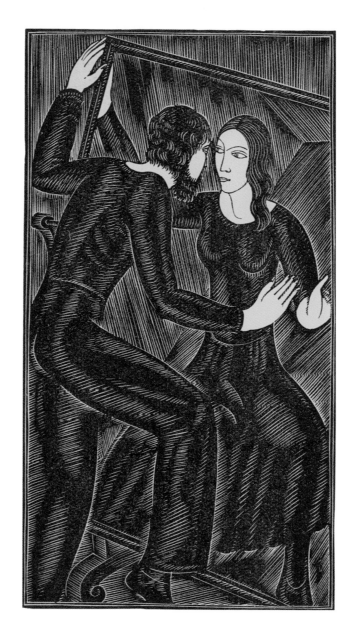

Artist and Mirror II, 1932.
Wood engraving for Gill's
book *Sculpture and the
Living Model*, 1932.
317 × 258 mm.

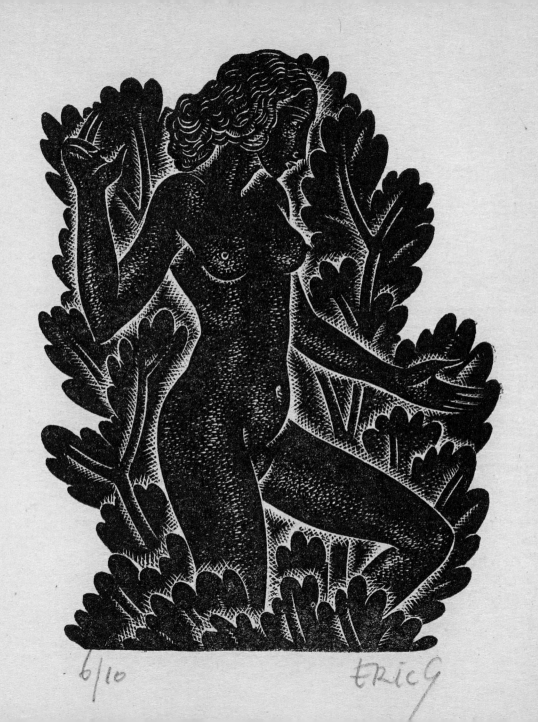

6/10 Eric G

(*Left*) *Belle Sauvage III*, 1929. Wood engraving, unused design for Gill's book *Art Nonsense and Other Essays*, Cassell, 1929. 78 × 60 mm.
This design was based on a life drawing of Gill's mistress Beatrice Warde.

(*Right*) *David*, 1926. Copper engraving, printed 1929, illustration for Gill's book *Id Quod Visum Placet*, printed by the Golden Cockerel Press, 1926. 112 × 69 mm.
In the book Gill refers to the slug as an object of beauty in spite of its repulsive associations: 'a slug may be seen as a thing of beauty in itself' (page 17). (See also page 97 of this book).

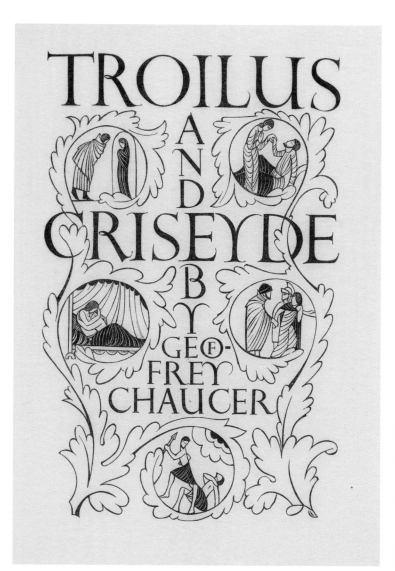

(*Left*) *Troilus and Criseyde Title Page*, 1927. Wood engraving, printed 1929, for Geoffrey Chaucer's *Troilus and Criseyde*, Golden Cockerel Press, 1927. 179 x 111 mm.

(*Right*) *Approaching Dawn*, 1927. Detail of wood engraving for Geoffrey Chaucer's *Troilus and Criseyde*, Golden Cockerel Press, 1927. 178 x 115 mm.

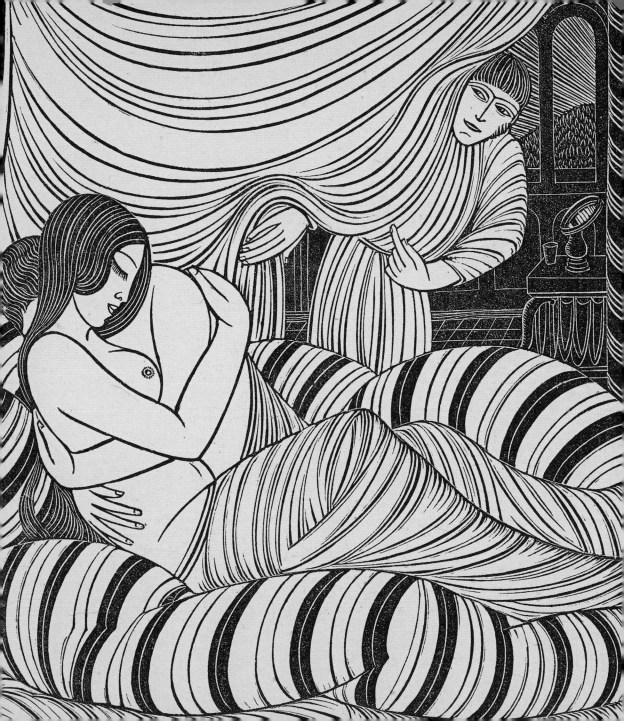

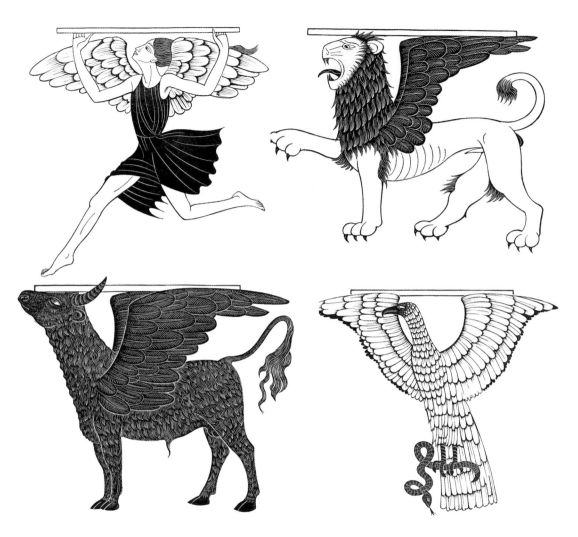

The Four Evangelists: *Angel of St Matthew* (148 × 140 mm), *Lion of St Mark* (113 × 142 mm),
Bull Calf of St Luke (120 × 142 mm) and *Eagle of St John* (150 × 165 mm), 1931.
Wood engravings for *The Four Gospels*, Golden Cockerel Press, 1931.

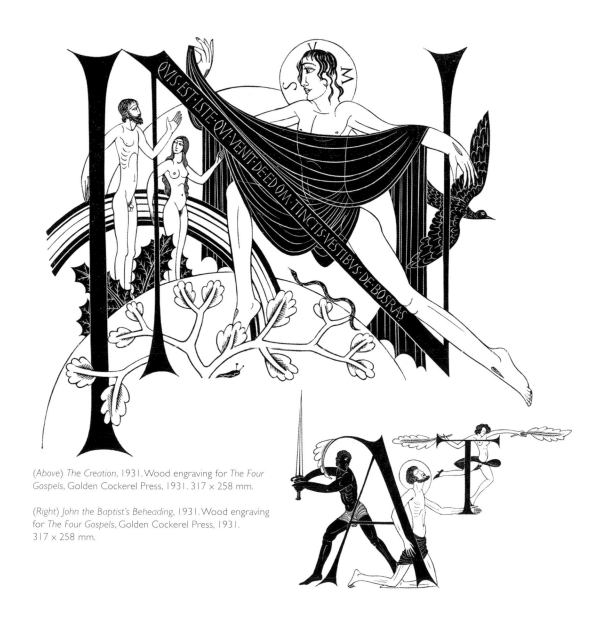

(*Above*) *The Creation*, 1931. Wood engraving for *The Four Gospels*, Golden Cockerel Press, 1931. 317 × 258 mm.

(*Right*) *John the Baptist's Beheading*, 1931. Wood engraving for *The Four Gospels*, Golden Cockerel Press, 1931. 317 × 258 mm.

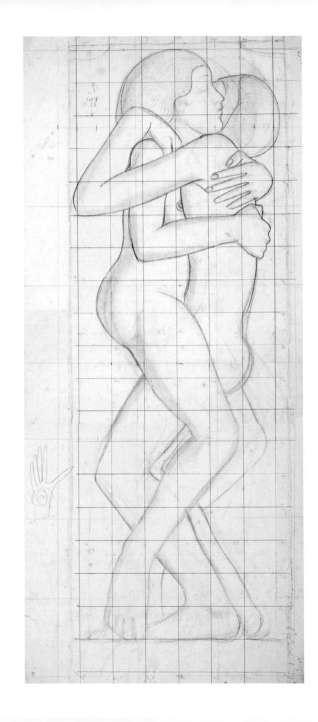

IT ALL GOES TOGETHER

It all goes together – industrialism and the leisure state, the potentially contemplative prostituted to the active, the sacred to the profane.

'IT ALL GOES TOGETHER', 1936, in *Essays: Last Essays and In a Strange Land* (1947)

Gill believed that work and honourable labour were essential to the happiness and stability of individuals and society. Workers with personal responsibility made 'works of love, of prayer, of contemplation'. For Gill, the separation of the one who made from the one who designed, as well as the separation of work from leisure and the Church from the social, contributed to what he saw as the breakdown and immorality of society and of art.

Gill's connected view of the world is particularly clear in the merging of his views on religion and sex. He drew on a tradition in Christianity of sexual metaphors relating to Christ: 'Now man taken abstractly as the bride of God is female. Hence the Church is the bride of Christ' ('Art & Prudence', *Beauty Looks After Herself*, London, 1933). This idea derived from the Old Testament Song of Songs and from St Paul's use of the analogy of marriage to describe the relationship between Christ and the Church (Paul, Ephesians 5, 22–33). The concept was also found in the poetry of St John

Ecstasy, undated (1910). Pencil drawing squared for enlargement (William Andrews Clark Memorial Library, University of California, Los Angeles). 381 x 914 mm.
This is Gill's working drawing for his 1910–11 sculpture *Ecstasy* (page 79). He envisaged this sculpture as part of a 'modern Stonehenge', which he planned to construct with Jacob Epstein.

99

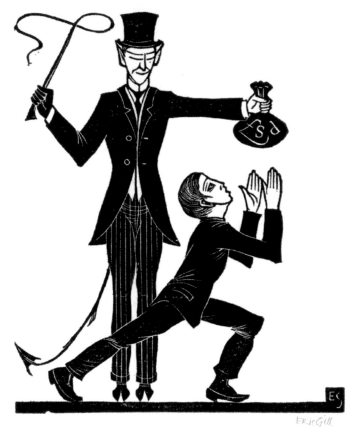

The Money Bag and the Whip, 1915. Wood engraving for Douglas Pepler's *The Devil's Devices*, 1915 (see also page 68). 190 × 131 mm. Gill represented the working man tempted by money into the capitalist system that enslaves him.

of the Cross (1542–1591), the Spanish mystic, who used the imagery of the spiritual marriage between Christ and his followers. Gill's three sets of illustrations for *The Song of Songs* (see page 89) overlapped with other representations of sexuality.

Gill's connected view of the world often prompted his use of religious imagery in secular commissions. It also often led him to reuse ideas and imagery in different media. The image created for his sculpture *Ecstasy* reappeared in wood engravings and other sculptures.

Laocoön, 1934. Wood engraving, design for the cover of Gill's *Art and a Changing Civilisation*, 1934 (private collection). 190 × 139mm.
The image represents Gill's view of Art as a victim of twin serpents, representing money (the pawnbroker's symbol of three spheres) and the devil (the serpent's tongue is the devil's tail).

Through Gill's art, and in particular some of the graphic work in the British Museum, one can see clearly the coming together of his ideas on work, art, sex, politics and religion. Gill believed work and labour, sexual intercourse and prayer were all acts carried out in the name of God and could be seen as religious activities. He saw personal responsibility for one's actions, and not the assumed responsibility of the Church, state or industry, as key to social and moral harmony. Gill positioned himself as a kind of prophet, a scourge against the diabolic forces of capitalism and authority, the enemies of art and religious life: 'man ... must reaffirm the freedom of his will and his consequent responsibility for all his deeds and works ... Then shall Babylon be destroyed' (*The Lord's Song*, 1934).

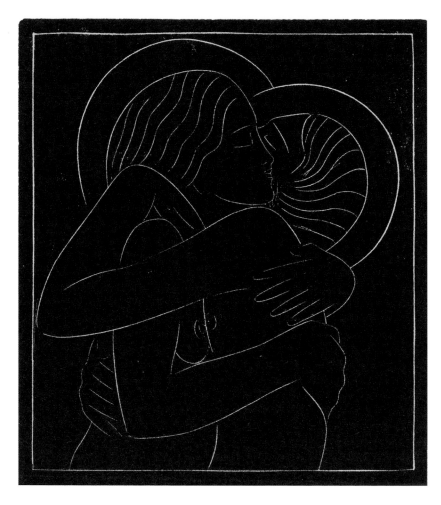

(*Above*) *Divine Lovers*, 1922. Wood engraving, reworking the design for *Ecstasy* (pages 79 and 98) to represent Gill's interpretation of the marital union between Christ and his Church. 89 × 76 mm.

(*Right*) *Icon*, 1922. Pewter, cast (Ditchling Museum). 82 × 72 × 8 mm.
This small sculpture was cast from a carving Gill made using the *Divine Lovers* block (*above*).

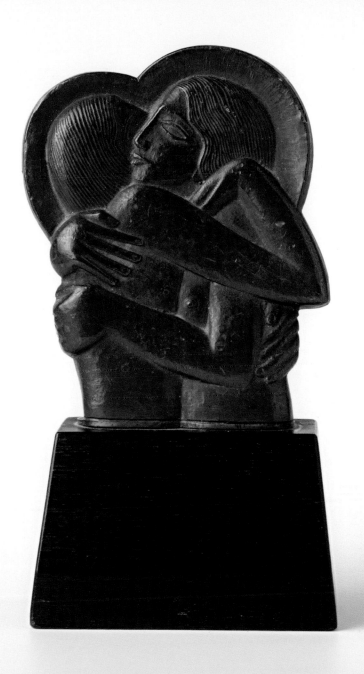

Man and woman having sex in canopied bed, undated. Preliminary pencil sketch for Gill's wood engraving *Our Bed Is All of Flowers* (*below*), on back of drawing of couple having sex (see page 81). 245 × 375 mm.

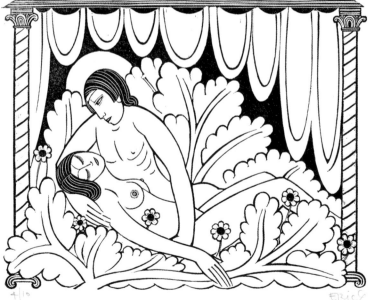

Our Bed Is All of Flowers, 1927. Wood engraving for St John of the Cross's *Song of the Soul*, Francis Walterson, Capel-y-Ffin, 1927, translated by Gill's friend Fr John O'Connor. 88 × 110 mm.

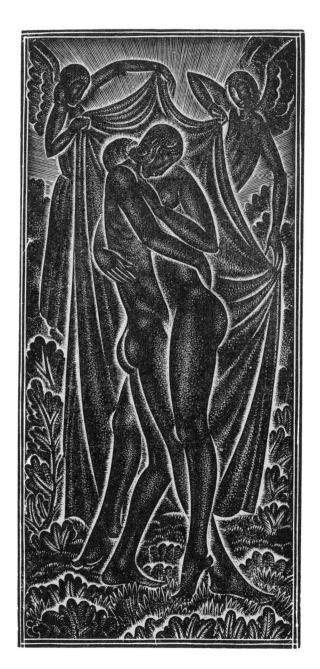

In Domum Matris Meae
(In my mother's house),
1930. Wood engraving
for *Canticum Canticorum*,
Cranach Press, 1931 (see
also page 89).
317 × 258 mm.

The Sower, undated. Preliminary pencil sketch for Gill's wood engraving *The Sower*. 360 × 250 mm.
This and another preliminary sketch for a wood engraving are on the back of one of the drawings in Gill's album of erotica.

(*Above*) *The Sower*, 1931. Wood engraving illustrating the parable of the sower for *The Four Gospels*, Golden Cockerel Press, 1931. 317 × 258 mm.

(*Right*) *The Sower*, 1932. Workshop photograph of the Hoptonwood sculpture made for the BBC building, Portland Place, London (Hesburgh Libraries, University of Notre Dame, Indiana).
Gill wrote to his brother Cecil, 29 August 1932, 'I am about to begin the sculpture, representing a man "Broadcasting", to stand in the entrance hall. Comic thought, when you consider the quality of B.B.C. semination, to compare it with the efforts of a simple countryman sowing corn!' (Walter Shewring, *Letters*, page 266).

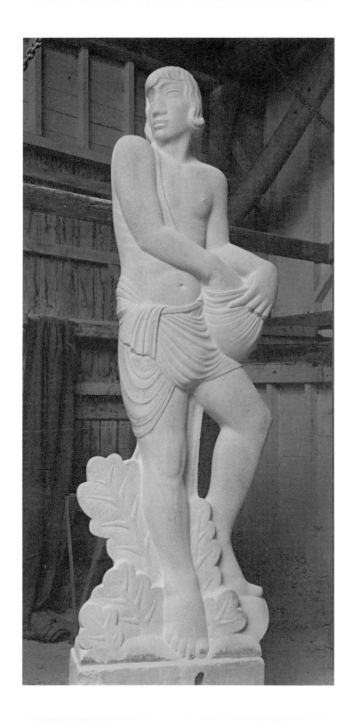

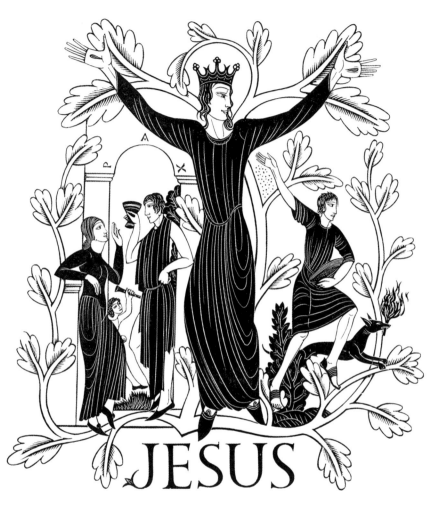

Christ Crowned, 1931. Wood engraving for *The Four Gospels*, Golden Cockerel Press, 1931. 317 × 258 mm.
Gill included images of the sower and heavenly lovers in this engraving. The hound of St Dominic also appears (see page 3). The child with a pipe seems to refer to the image of Ariel in Gill's sculpture of Prospero and Ariel for the front of the BBC. Gill again subverted the BBC's intention, as he deliberately gave the child the stigmata of Christ, transforming Prospero and Ariel into God the Father and the Christ Child. The child in this religious engraving reinforces this reading.

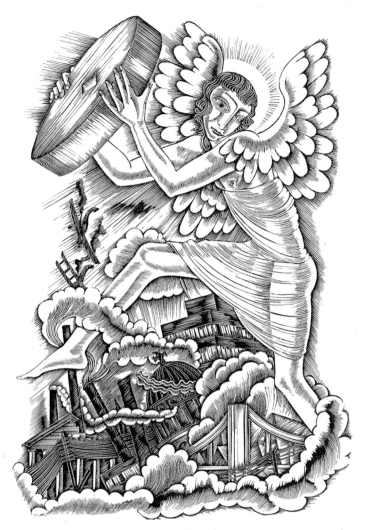

Apocalypse, 1936. Wood engraving for the Aldine Bible, 1936. 155 × 108 mm.
Gill shows the angel of destruction casting a millstone on the modern Babylon
(Revelation 18:21). Babylon is represented by him as a modern city with aeroplanes,
a church, a museum, an office block, factories and telephone wires.

SELECTED READING

AUTOBIOGRAPHY

Gill, Eric, 1940, *Autobiography*, Jonathan Cape, London.

Shewring, Walter (ed.), 1947, *Letters of Eric Gill*, Jonathan Cape, London.

BIOGRAPHY

MacCarthy, Fiona, 1989, *Eric Gill*, Faber, London.

Speaight, Robert, 1966, *The Life of Eric Gill*, Methuen & Co., London.

BIBLIOGRAPHY

Gill, Evan, 1991, *Eric Gill: A Bibliography*, D. Stephen Corey & Julia Mackenzie (eds), 2nd edn, St Paul's Bibliographies, Winchester.

INSCRIPTIONS

Gill, Evan, 1964, *The Inscriptional Work of Eric Gill*, Cassel & Co., London.

Johnston, Edward, 1906, *Writing & Illuminating & Lettering*, Macmillan, London.

Peace, David, 1994, *Eric Gill: The Inscriptions*, Herbert Press, London.

SCULPTURE

Collins, Judith, 1992, *Eric Gill: Sculpture*, Lund Humphries in association with Barbican Art Gallery, London.

ENGRAVINGS

Gill, Eric, 1916, *Wood Engravings*, St Dominic's Press, Ditchling.

Gill, Eric, 1929, *Engravings by Eric Gill: A Selection*, Douglas Cleverdon, Bristol.

Gill, Eric, 1934, *Engravings by Eric Gill, 1928–33*, Faber, London.

Physick, John, 1963, *The Engraved Work of Eric Gill* (catalogue), Victoria & Albert Museum, London.

Selborne, Joanna, 1998, *British Wood-Engraved Book Illustration, 1904–40*, Clarendon, Oxford.

Skelton, Christopher (ed.), 1990, *Eric Gill: The Engravings*, Herbert Press, London.

TYPOGRAPHY

Harling, Robert, 1976, *The Letter Forms and Type Designs of Eric Gill*, Westerham.

MONOGRAPHS

Cribb, Ruth, & Cribb, Joe, 2007, *Eric Gill and Ditchling: The Workshop Tradition*, Ditchling Museum, Ditchling.

Yorke, Malcolm, 1982, *Eric Gill: Man of Flesh and Spirit*, Universe Books, New York.

ILLUSTRATED BOOKS

WRITTEN AND ILLUSTRATED BY GILL

1926, *Id Quod Visum Placet*, Capel-y-Ffin (printed by Golden Cockerel Press, Waltham St Lawrence).

1929, *Art Nonsense and Other Essays*, Cassell & Co.; Francis Watterson, London.

1932, *Sculpture and the Living Model*, Sheed & Ward, London (printed by Gill and Hague, High Wycombe).

1933, *Beauty Looks after Herself: Essays*, Sheed & Ward, London.

1934, *Art and a Changing Civilisation*, Bodley Head, London.

1938, *25 Nudes*, Dent & Sons Ltd, London (printed by Gill and Hague).

1939, *Social Justice and the Stations of the Cross*, Clarke & Co., London (printed by Gill and Hague).

1947, *Essays: Last Essays and In a Strange Land*, Jonathan Cape, London.

ILLUSTRATED BY GILL FOR THE GOLDEN COCKEREL PRESS

Clay, Enid, 1925, *Sonnets and Verses*.

1925, *The Song of Songs*.

1926, *Passio Domini Nostri Jesu Christi*.

Chaucer, Geoffrey, 1927, *Troilus and Criseyde*.

Chaucer, Geoffrey, 1929, *Canterbury Tales*.

1931, *The Four Gospels*.

ILLUSTRATED BY GILL FOR OTHER PRESSES

Pepler, Douglas (also called Hilary), 1915, *The Devil's Devices – or Control versus Service*, Hampshire House Workshops, London.

Pepler, Douglas, 1916–23, *The Game*, St Dominic's Press, Ditchling.

Pepler, Douglas, 1917, *God and Dragons*, St Dominic's Press, Ditchling.

St John of the Cross, 1927, *Song of the Soul* (translated by Gill's friend Fr John O'Connor), Francis Walterson, Capel-y-Ffin.

Canticum Canticorum (Song of Songs), 1931, Cranach Press, Weimar.

The Aldine Bible, 4 vols, 1936, J.M. Dent & Sons Ltd., London.

ACKNOWLEDGEMENTS

THANKS TO

John Sherman, Dennis Doordan and Tracy Bergstrom at the University of Notre Dame, Indiana; Bruce Whiteman, Suzanne Tatian, Scott Jacobs and Candis Snoddy at the William Andrews Clark Memorial Library, University of California, Los Angeles; Kevin Clancy and Graham Dyer at the Royal Mint; Hilary Williams, Natalie Franklin, Donna Steele and Jenny KilBride at Ditchling Museum; Sam Moorhead, Philip Attwood, Eleanor Bradshaw, Angela Roche, Janice Reading and Stephen Coppel at the British Museum; Mary Morris, Coralie Hepburn, Axelle Russo and Caroline Brooke Johnson at British Museum Press; Vicky Wharton; Peter Green; and Roger and Ginny Broadbent. Special thanks to Marcus Lang and Margaret Cribb and all the Cribb family.

ILLUSTRATION ACKNOWLEDGEMENTS

Except where otherwise stated, photographs are © The Trustees of the British Museum. British Museum registration numbers are listed below. You can find out more about objects in all areas of the British Museum collections at www.britishmuseum.org.

i PD 1931,0803.3; ii PD 1949,0411.971; iii Private collection; v (l) PD 1927,0712.75; v (r) PD 1927,0712.75; 6 PD 1930,0306.3; 9 Ditchling Museum; 10 PD.1921,1028.21 (Given by Douglas Pepler); 11 PD 1931,0803.15; 13 PD 1936,0510.2 (Given by Dr Herman T Redin); 15 PD 1924,0209.89; 17 CM 1934,0703.2 (Given by George Taylor Friend); 18 The Royal Mint; 20, 21 G&R 1805,0703.202; 21, 22-23 EG 220; 24 EG 394; 25 PD 1973,0120.24; 26 William Andrews Clark Memorial Library; 27 CM; 28 The Royal Mint; 29 CM; 30-31, 32 (r) William Andrews Clark Memorial Library; 32 (l, top) CM E 5219; (l, middle) CM 1950,0606.57; (l, bottom) CM 2002,0101.1270 (Bequeathed by Charles A Hersh); 33 The Royal Mint; 34 PD 1925,0725.3 (Given by Eric Gill); 36 PD 1986,0510.11;

37 PD 1930,0306.131; 38 Hesburgh Libraries; 39 PD 1926,0313.72; 40 PD 1926,0313.69; 41 PD 1930,0306.71; 42 PD 1981,0725.24; 43 PD 1981,0725.23; 44 PD 1930,0306.78; 45 PD 1930,0306.65; 46 CM 1924,0217.1 (Given by George Taylor Friend); 47 PD 1930,0306.79; 48 PD 1920,1211.1; 50 PD 1916,0612.41; 52 PD 1916,0428.14; 53 PD 1949,0411.964; 54 PD 1918,1010.40; 55 (top r) PD 1916,1003.10; 55 PD 1921,1028.10; 56 PD 1920,1211.1; 57 (top l) PD 1920,1211.1; (bottom l) Hesburgh Libraries; (top r) PD 1949,0411.22; (bottom r) Courtesy of Peter Green; 58-59 PD 1918,1010.41; 60 PD 1922,0708.32; 61 Private collection; 62 PD 1918,1010.39; 64 PD 1925,1117.14; 66 CM 1977,0105.1; 67 PD 1930,0306.8; 68 PD 1925,1117.13; 69 PD 1916,0428.11; 70 PD 1925,1117.14; 71 PD 1918,1010.37 (Given by Douglas Pepler); 72 PD 1921,1028.13 (Given by Douglas Pepler); 73 PD 1921,1028.12; 74 PD 1977,U.504.62; 76 PD 1977,U.504.85; 77 PD 1977,U.504.104; 78 PD 1977,U.504.84 ; 79 Private collection; 80 PD 1977, U.504.88; 81 PD 1977, U.504.90; 82 PD 1977, U.504.103; 83 (l)PD 1930,0111.119; (r) PD 1977,U.504.113; 84 PD 1928,0310.37; 85 Ditchling Museum; 86 PD 1920,1209.8 (Given by Robert Gibbings); 88 PD 1949, 0411.5103;

89 PD 1930,0306.120; 90 PD 1928,0310.35; 91 PD 1949,0411.5103; MM.4.18 p. 101; 92 PD 1932,0623.19 93 PD 1930,0306.132; 94 PD 1930,0306.144; 95 PD 1927,0712.91; 96 PD 1941,0208.49.a (top l); b (top r); c (bottom l); d (bottom r); 97 (top) PD 1949,0411.5103; MM.4.18 p. 91; 97 (bottom) PD 1949,0411.5103; MM.4.18 p. 78; 98 William Andrews Clark Memorial Library; 100 PD 1925,1117.13 p. 31; 101 Private collection; 102 PD 1924,0209.92; 103 Ditchling Museum; 104 (top) PD 1977, U.504.90 (back); (bottom) PD 1949,0411.969; 105 PD 1949,0411.5103; MM.4.18 pl. 63; 106 (l) PD 1977, U 504.40; (r) PD 1949,0411.5103; MM.4.18 pl. 63; 107 Hesburgh Libraries; 108 PD 1949,0411.5103; MM.4.18 pl. 95; 109 PD 1936,0812.8

The works illustrated on pp. 15, 39, 40, 48, 56, 57, 60, 83, 84, 90, 96 and 102 were acquired through the Contemporary Art Society; those on pp. i, 50, 52, 53, 57, 58-9, 62, 69, 88, 91, 104 and 109 were donated by Campbell Dodgson; those on pp. 36, 41, 44, 45, 47, 64, 67, 70, 89 and 93 were transferred from the British Library. All other donor information is given above.

INDEX